DAVID LARNED

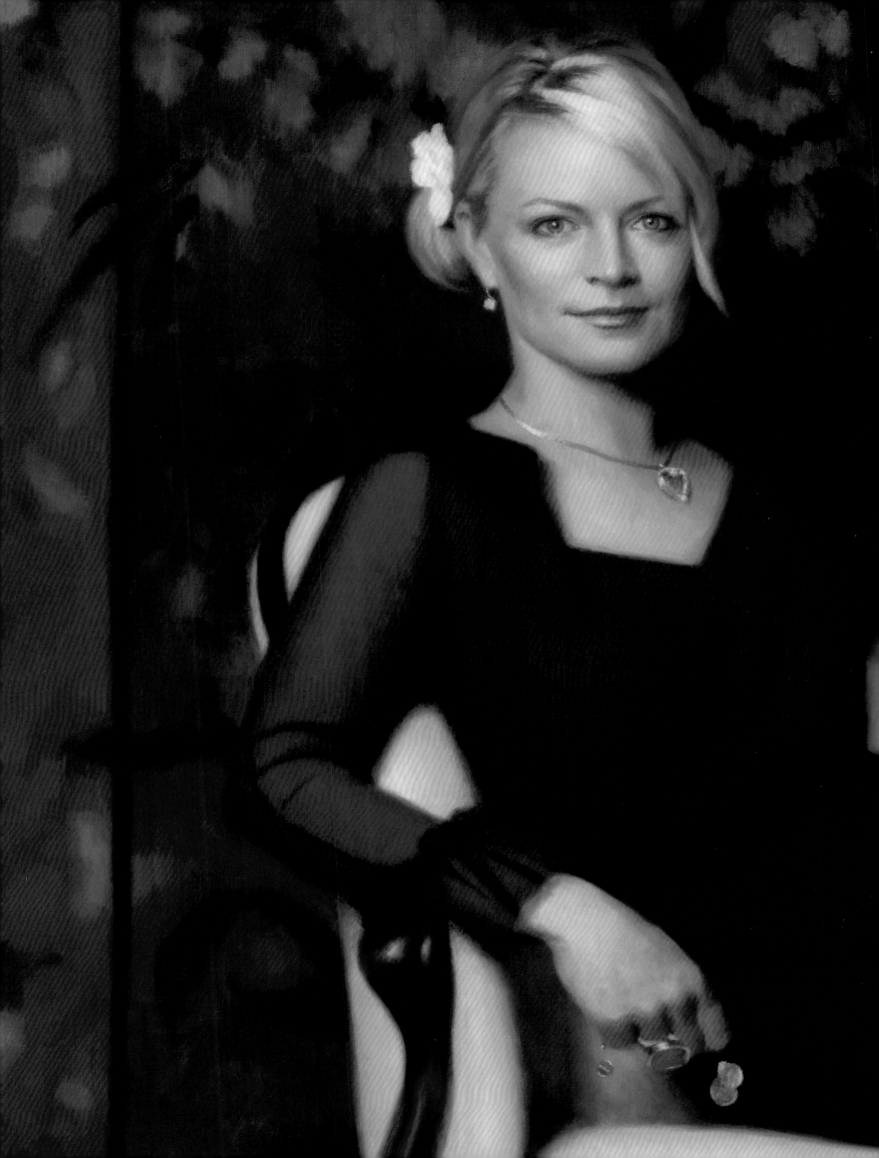

DAVID LARNED
PORTRAITS

Contributions by Peter Trippi & Karol Schmiegel

Brilliant Press

This book was designed, printed, and manufactured in the U.S.A. in 2013 by Brilliant Press, Exton, PA.

ISBN: 978-0-9897627-1-7

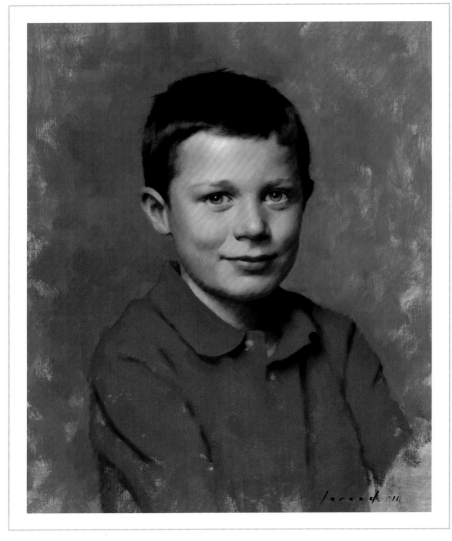

Rudy, Oil, 18" x 14"

FRONT COVER DETAIL:
Sabrina
Oil, 82" x 40"

TITLE PAGE SPREAD DETAIL:
Kirstie
Oil, 33" x 41"

CONTENTS

"The purpose of art is to wash the dust
of daily life off our souls."

- Pablo Picasso

FOREWORD

In an era when many artists ignore the past's lessons to their own detriment, it is a rare pleasure to encounter the portraits of David Larned. Those who prioritize novelty may hear this as damning praise. If so, they should listen again. The finest creations of such portraitists as Rubens, van Dyck, Velázquez, Sargent, Degas, Kinstler, and Shanks enrich us not only by putting a face on history and adorning museums, but also by revealing their secrets to men and women making art today. Consulted judiciously, these masters live on by helping later artists to find their own voices, to depict their own contemporaries effectively. Re-animating the past for its own sake constitutes a dead end, however, and works created in that mode can be spotted a mile away.

When you see a portrait by David Larned, expect to be caught off guard. The haircut, clothing, and accessories suggest the sitter walks among us, yet there is something ineffably timeless in both the treatment and the spirit. It's clear that Larned mastered the requisite technical skills (color, lighting, draftsmanship, brushwork) while training in Philadelphia and Florence, and also that he came to love and feel the examples his teachers set before him. Within the arena of painting full or partial figures on canvas in oil, there are only so many ways to proceed, but somehow Larned orchestrates and re-orchestrates only the parts essential to conveying his sitters' distinct personae.

These portraits have no standard look; each has been composed and executed elegantly and simply, in direct response to the sitter's individuality. Immediacy is assured, yet the camera does not reign here: Sitters' palpability is the result of serious looking at how opportunities can be maximized and problems solved, and of slipping behind the façade every human being initially presents to another.

If the hallmark of the professional is making hard work look easy, this is professionalism of a very high order. This is also artistry that should ultimately find its place in the long tradition of great portraiture, because somehow these pictures look as if they were always meant to be.

— **Peter Trippi**
Editor, *Fine Art Connoisseur* Magazine
& President, Projects in 19th-Century Art, Inc.

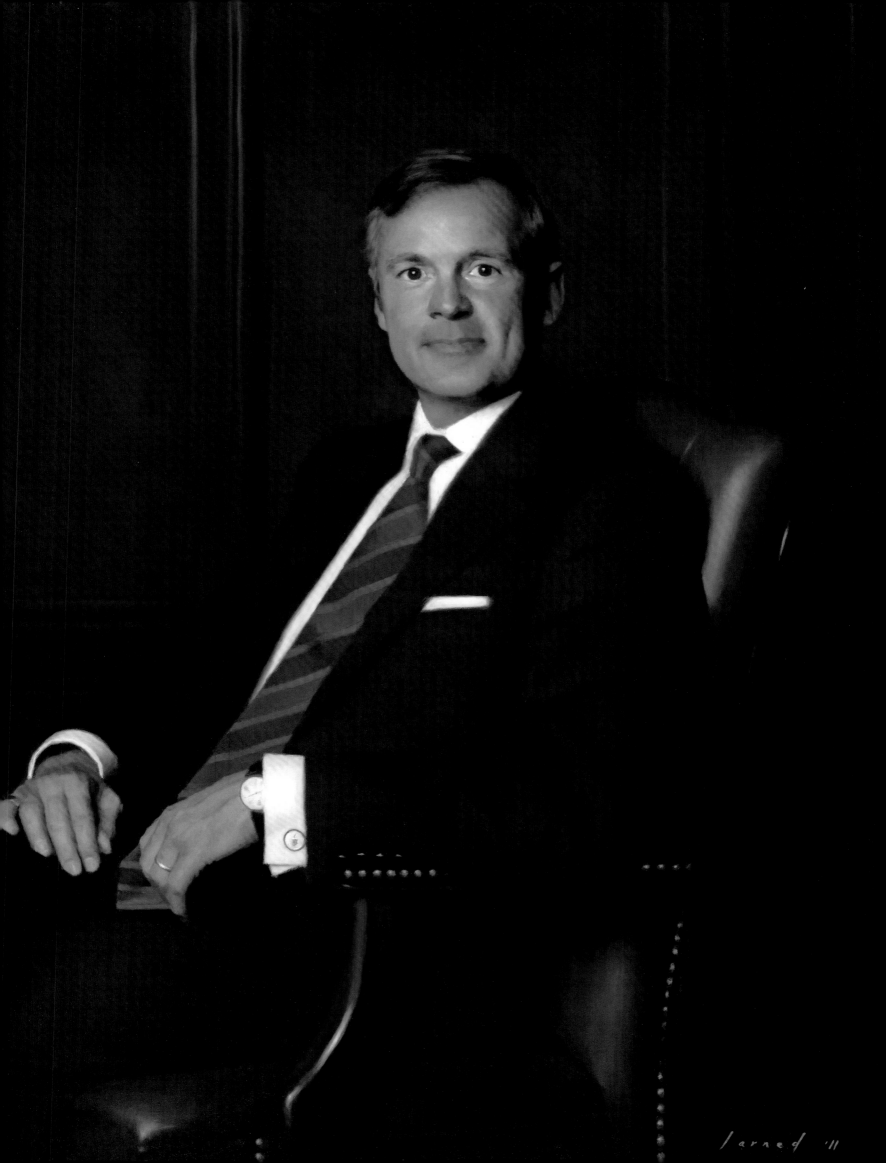

Charles du Pont, Detail

INTRODUCTION

The following pages are about people: visual representations of children, politicians, women, executives, and thinkers. On the surface, it is a collection of portrait paintings from the first decade of an artist's professional life. But more importantly it's about personalities, families, emotion, and identity—everything filtered through a brush. This book reveals the way these images were created and the life of a painting after it leaves the studio. The sections examine the painting process, inspiration, influences, composition, and style. Museum curators, critics, artists, professors, gallery owners, and connoisseurs have all contributed to the text herein.

"The pursuit of truth and beauty is a sphere of activity in which we are permitted to remain children all our lives."

THE PURSUIT OF PAINTING

I can't remember a time when I did not paint. Art was not something I chose. It has always been more fundamental than that. Like walking or eating, it's been just another basic, essential activity. It wasn't until Art History 101 when I saw Albrecht Dürer's Self Portrait from 1500 that I knew I would consciously dedicate the rest of my life to painting. When the image appeared on screen, I was driven back in my chair with a physical force. It was incredible. Electric. My passion for art officially began that day. After completing my degree, I set off for Florence.

The Florence Academy of Art was and still is based on the 19th century French Atelier method. Unlike American Contemporary Art education, which puts a premium on individual expression immediately (often at the expense of learning technique), the Academy believed in developing skill first and then using your well honed technique to express yourself later. The director's method was law. It was the master/apprentice system. If you submitted your will and creativity to the teacher's instruction, the expectation was that you too would be able to paint as well as he.

Albert Einstein

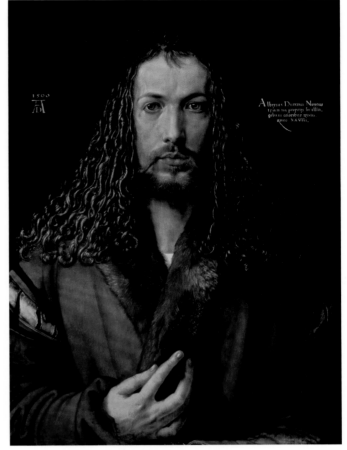

Self Portrait, Albrecht Dürer, German, Oil, 1500
© The Gallery Collection/Corbis

The uncompromising and tedious approach moved students through increasingly complicated exercises from drawing basic shapes in pencil, through cast work and still life, until finally graduating to the figure and portrait painting in full color. Learning the traditional way was arduous and not entirely painless, but once mastered provided the requisite skills to paint anything we desired. Like classically trained musicians can play any piece of music they are given, so too could we paint whatever inspired us. For me it was people.

Portraiture is something I gravitated toward slowly but inexorably. Its allure is magnetic. As soon as I finish one, I can't wait to start the next. Never getting it quite right, never quite as beautiful as it is in nature, but closer, I'm always trying to get closer to what makes the human image so profoundly sublime.

1

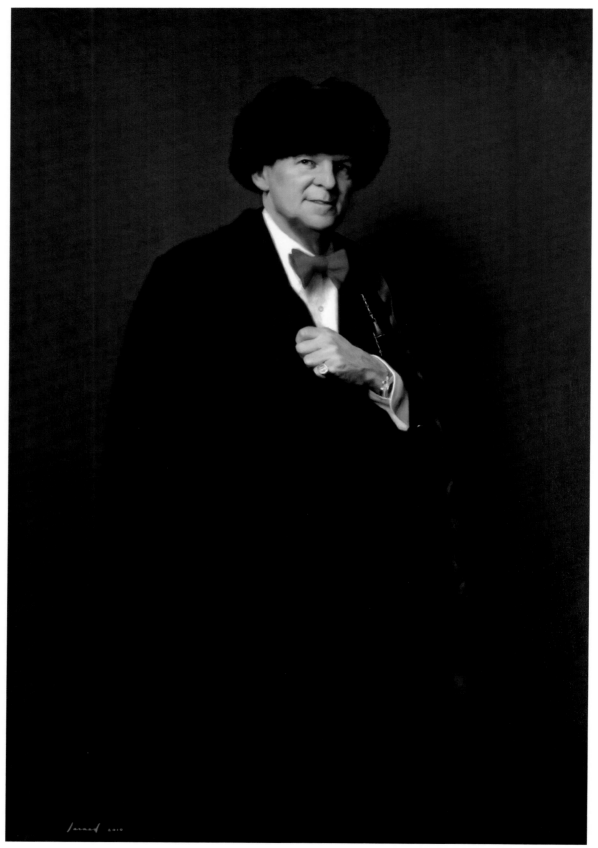

Charles du Pont, Oil, 55" x 37"

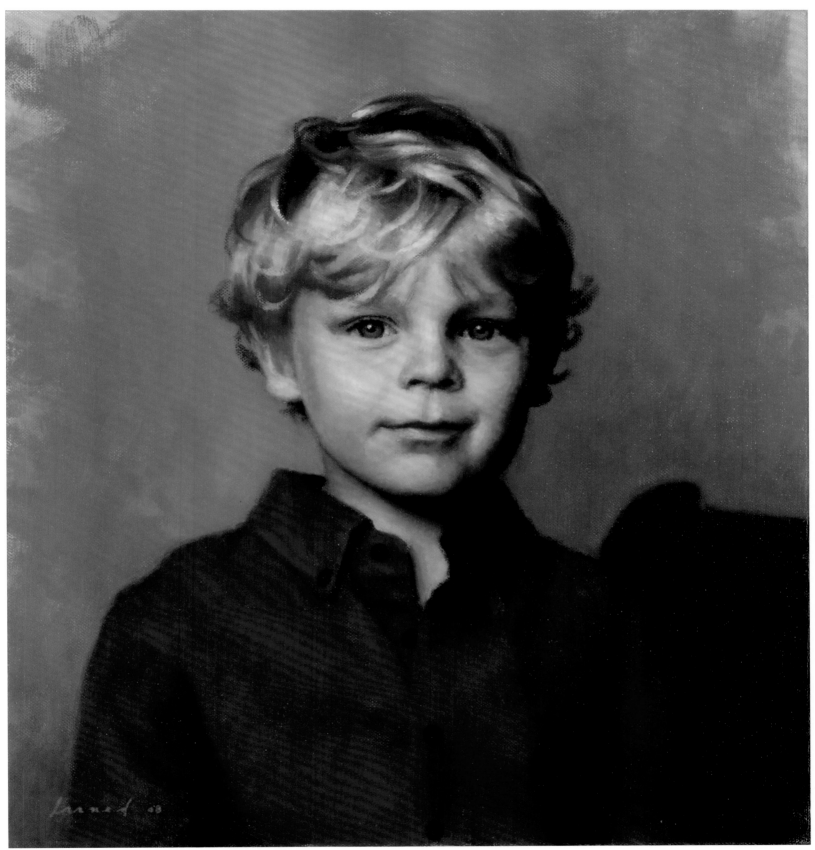

Grant, Oil, 16" x 14"

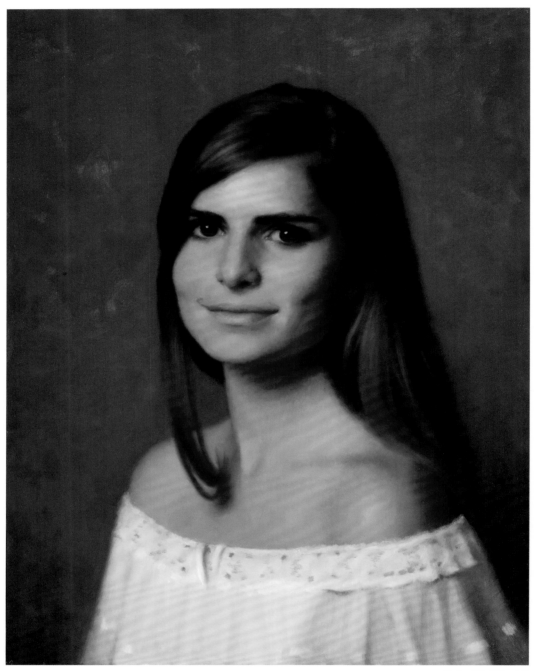

Kelly, Oil, 18" x 14"

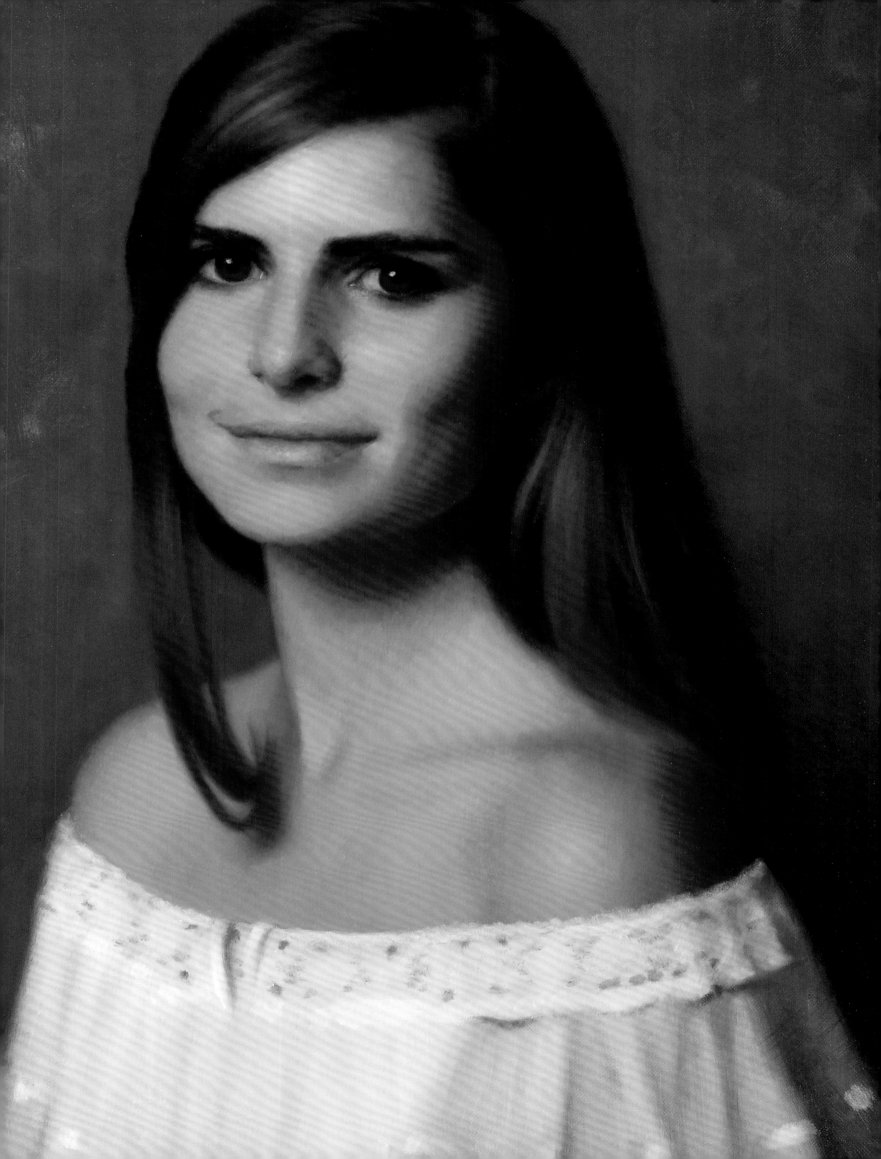

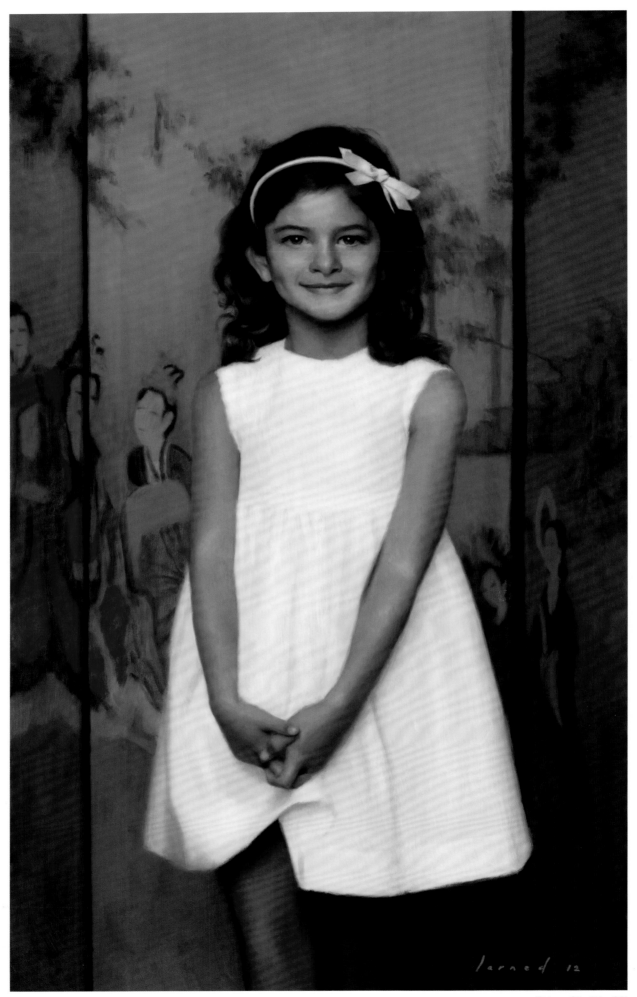

Chloe, Oil, 41" x 25"

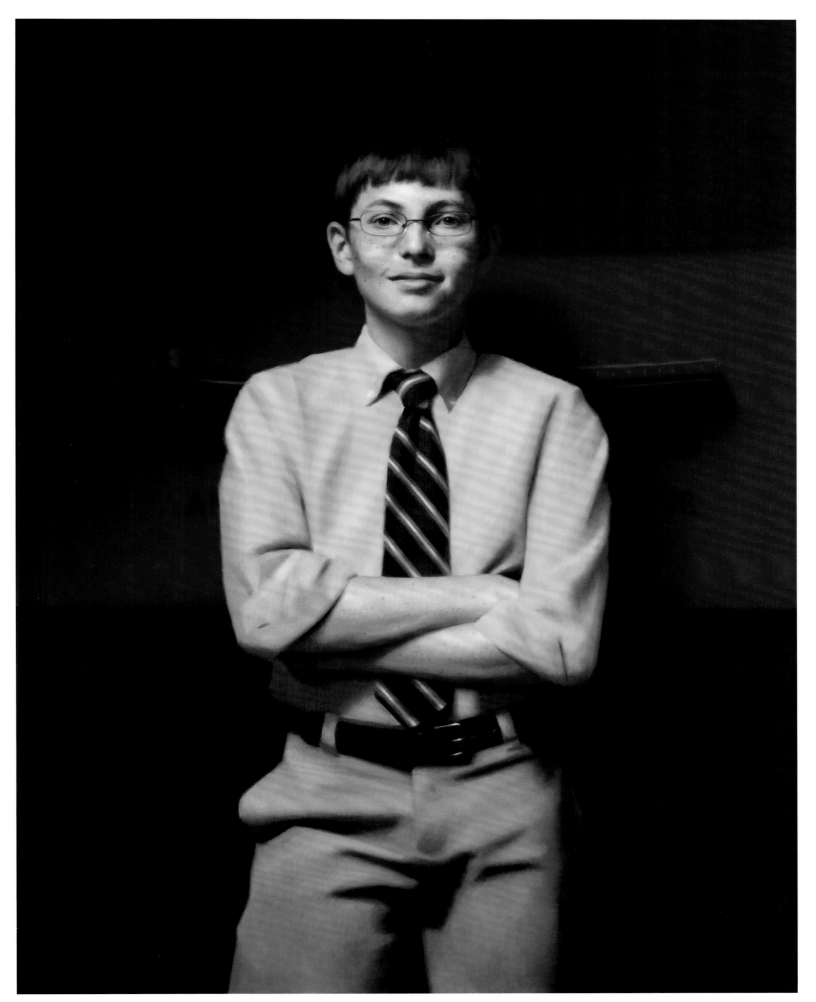

Philip, Oil, 40" x 32"

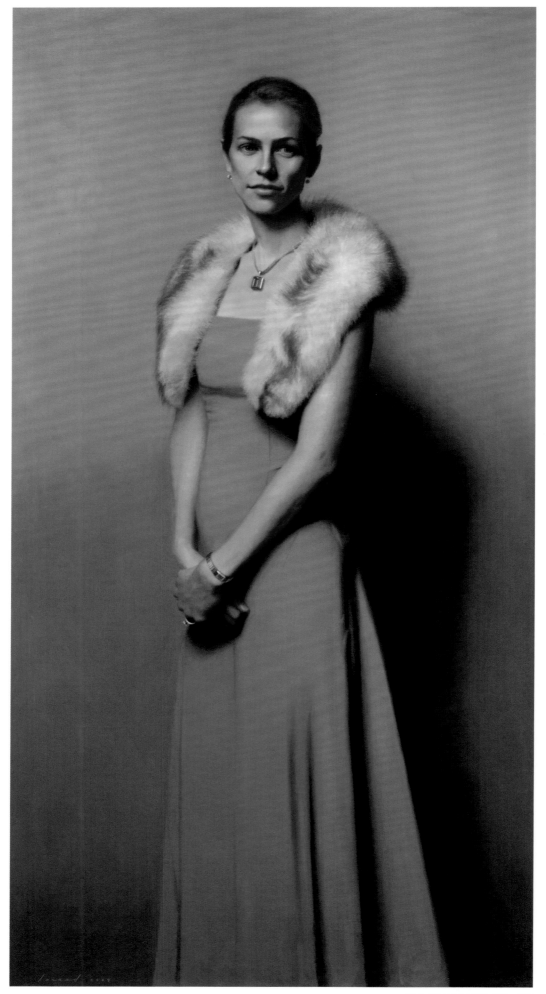

Mrs. Piasecki, Oil, 63" x 33"

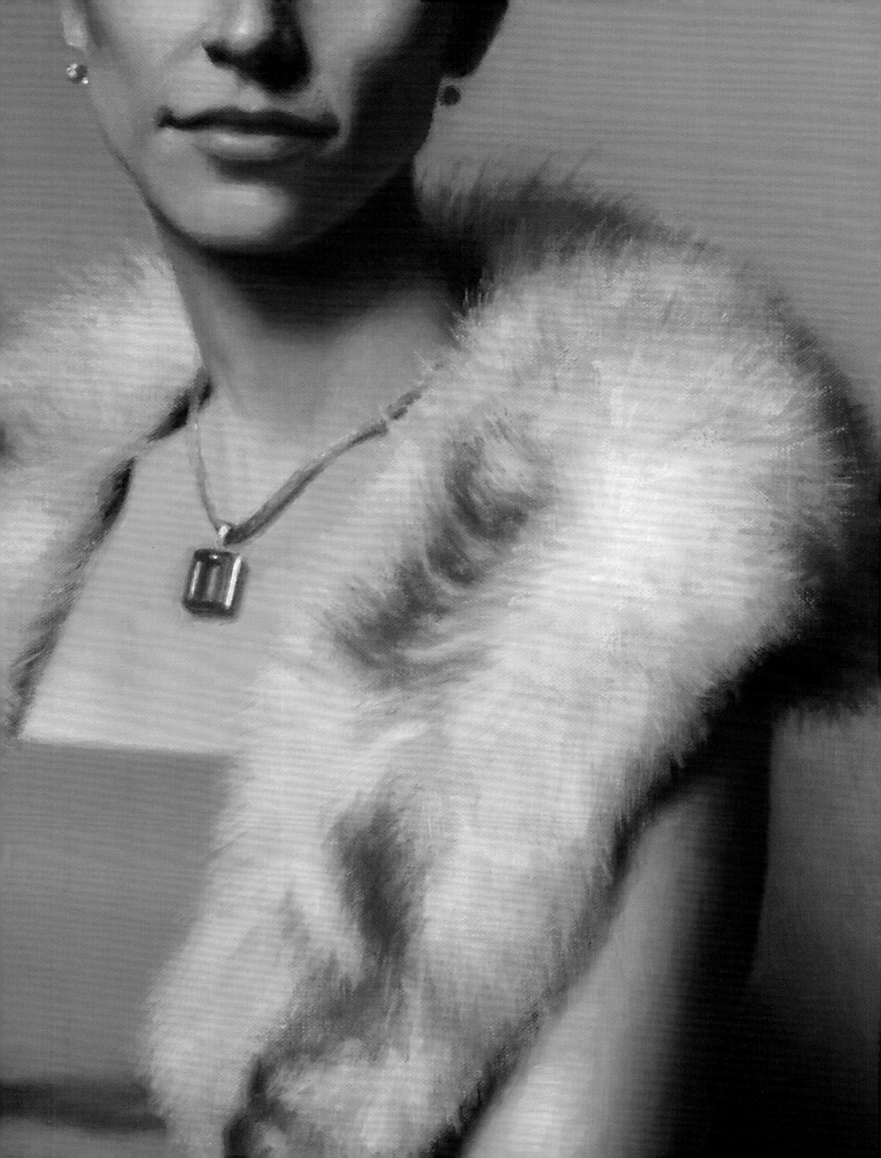

" I found I could say things with color and shapes that I couldn't say any other way—things I had no words for."

SELECTIVE VISION

"Learning to see" is what you go to art school for. It is the hardest part of becoming a painter. How do you distill and translate the infinite complexity of the three-dimensional visual world onto a two-dimensional surface? The great painters of the past have solved this central problem with as many different ways as there are artists. But the ones that speak to me, the ones that paint life with conviction and explain its beauty on canvas, all perceived less of nature than the rest. Sargent, Velazquez, and Vermeer were all extraordinary editors. They simplified and eliminated all of the superfluous to get to the essential. This is what is profound about their art, their selective vision. They could strip away the idiosyncrasies to reveal the core of their subject. It's not the freckle on the nose or the sheen of the fabric; it's the way light bathes a figure in space. This is how we see. This is what we respond to when we recognize someone from a distance; we perceive their shapes as a familiar whole, not as a collection of fragmented details. Like my heroes, I am trying to paint only the essence of someone, nothing more.

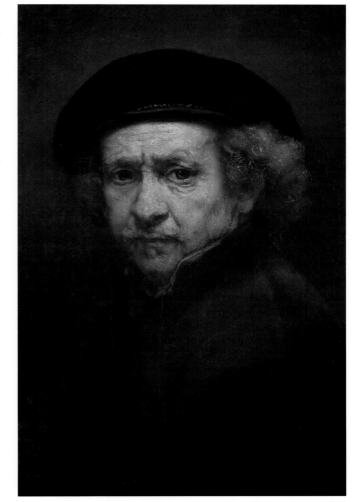

Self Portrait, Detail, Rembrandt van Rijn, Dutch, Oil, ca. 1659
© Francis G. Mayer/Corbis

After art school when there are no longer teachers to serve as guides, it becomes necessary to choose your artistic heroes for direction. Whether you turn to them for inspiration or simply to see how they resolved a technical issue, they become silent but indispensable mentors. Personally, John Singer Sargent, Diego Velazquez, Rembrandt, Anthony Van Dyck, and Johannes Vermeer have always been in the forefront of my mind when I paint. Others come and go, depending on what I am working on or what experiment I want to explore. Want more dynamism in a composition? Look to Rubens or Van Dyck. Want more drama? Look to Caravaggio or Rubens. Want more elegance? Look to Ingres or David. Standing on the shoulders of the past masters not only informs and improves your art but also locates it within the arc of art history.

Georgia O'Keefe

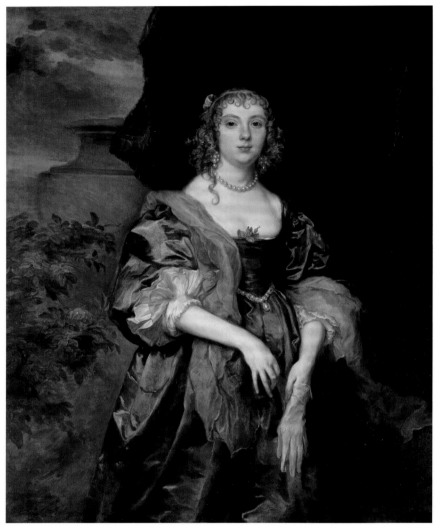

Anne Carr, Countess of Bedford, Anthony Van Dyck, Flemish, Oil, ca. 1638
© The Gallery Collection/Corbis

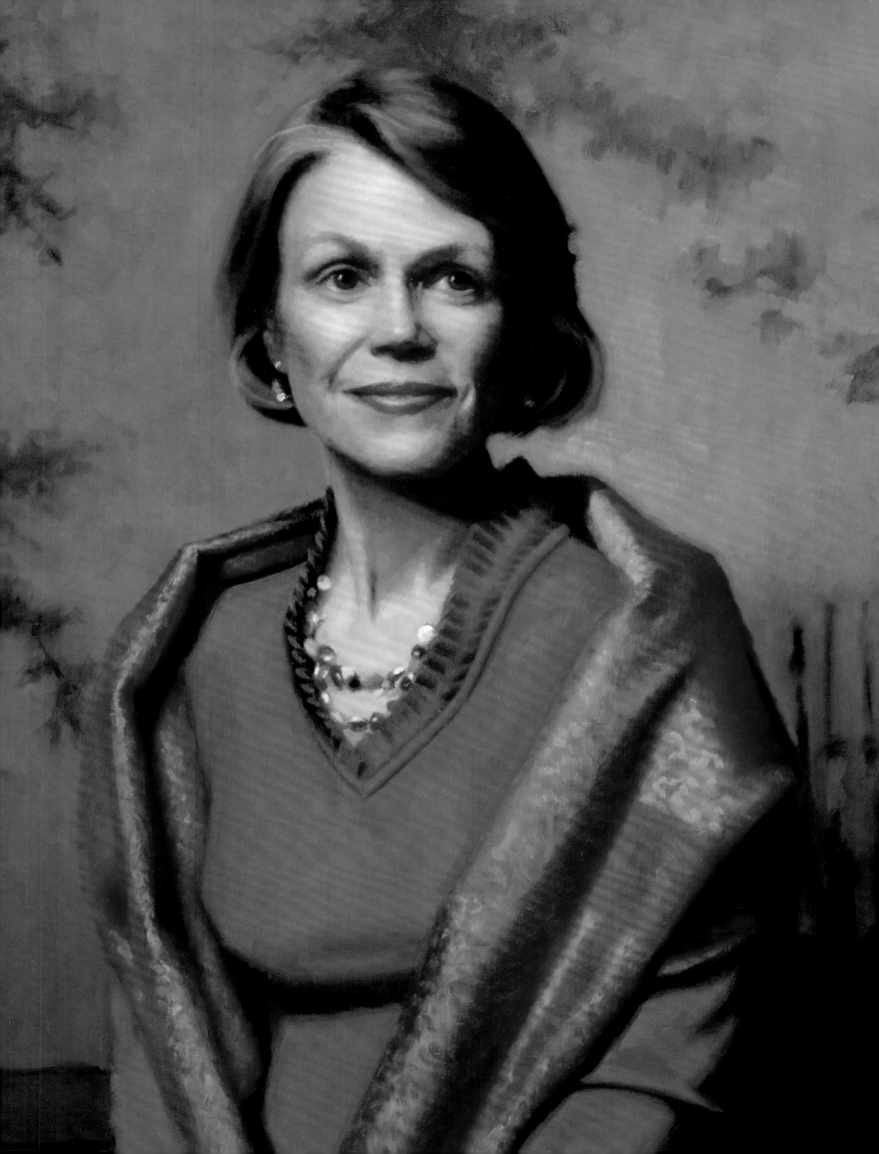

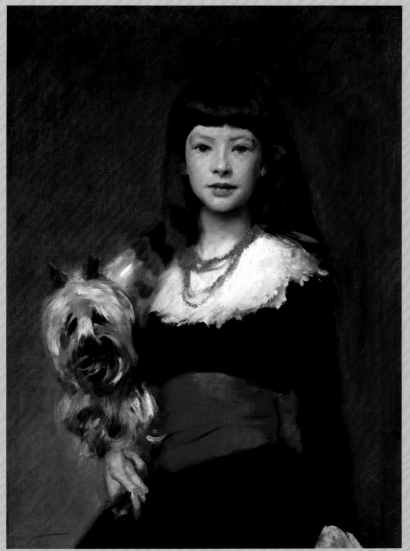

Beatrice Townsend, John Singer Sargent, American, Oil, ca. 1882
© Geoffrey Clements/Corbis

US Bankruptcy Court, District of DE, Chief Judge, The Honorable Helen S. Balick, Oil, 27" x 24"

"Everything has beauty, but not everyone sees it."

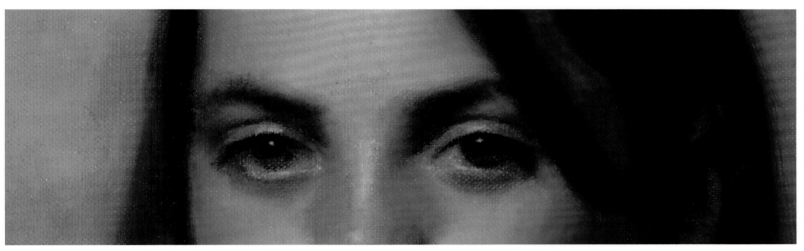

Lily, Detail

FORMING THE WORK

Classical painting is rooted in drawing. There have been no great painters who weren't masterful draftsmen. It is the foundation upon which color is laid. A successful portrait draws its structure and strength (not to mention likeness) from drawing. Color is merely an adornment. It should be noted that "drawing" in a painting is actually done in paint (as opposed to drawing in the sense of using dry media).

Once the concept for a portrait is established, it is imperative to hold that initial inspiration firmly in mind until you have successfully recreated it for others to see on canvas. The painting process is a slow evolution of constant revision and refinement. You could say a painting starts off all wrong, and as you gradually improve it piece by piece, you eventually end up with a finished painting.

After the composition is determined, the broadest most basic contours of the subject are sketched in (see step 1 on page 20). Next the light and shadow shapes are indicated (see step 2). Once comfortable with this stage (at which point a likeness is already emerging), you move on to the large color statements (see step 3). A background tone, a tone to represent the light mass, one for the shadow, and perhaps one for clothing are roughly "blocked" in to begin judging the dominant color relationships. From here, everything starts to slow down. Like the framing of a house, the early stages seem to develop rather quickly while the finishing stages seem to be very slow. Once the big statements of drawing and color are established, you begin to refine the component parts (see step 4). This shape becomes smaller, this red darker, this edge a little softer etc. You are always comparing your subject with your painting, working your eyes back and forth between the two, discovering the differences and similarities. The discrepancies tell you what needs to be addressed. The similarities can be pushed and managed toward your goals. The attack is like triage—always correcting the worst part, then moving on to the next worst, and so on. Strangely, and perhaps unsatisfyingly, you know when a painting is finished when you arrive at a stalemate. When you no longer know what to fix or improve, when you are at a loss, you are finished (see step 5).

Confucius

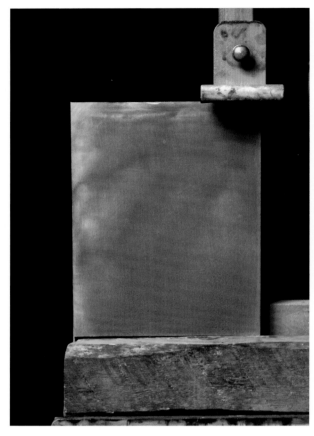

Preparation A white canvas is covered with a
neutral tone.

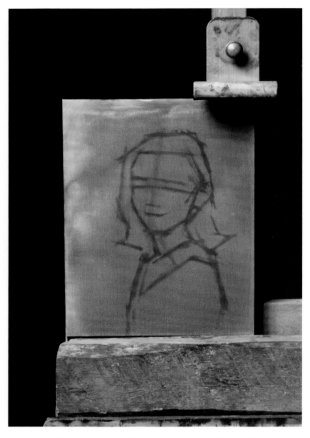

Step 1 The most basic parameters of the figure are
roughly indicated.

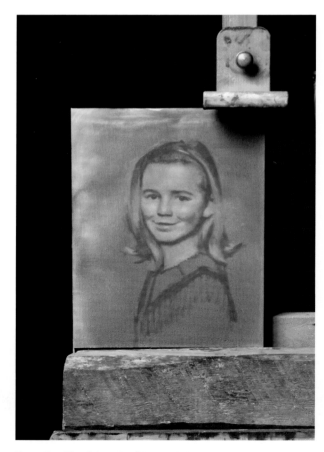

Step 2 The "drawing" is established by massing in
light and shadow.

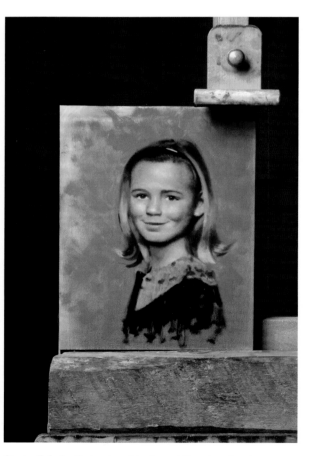

Steps 3 & 4 Color is added, and the drawing is
refined.

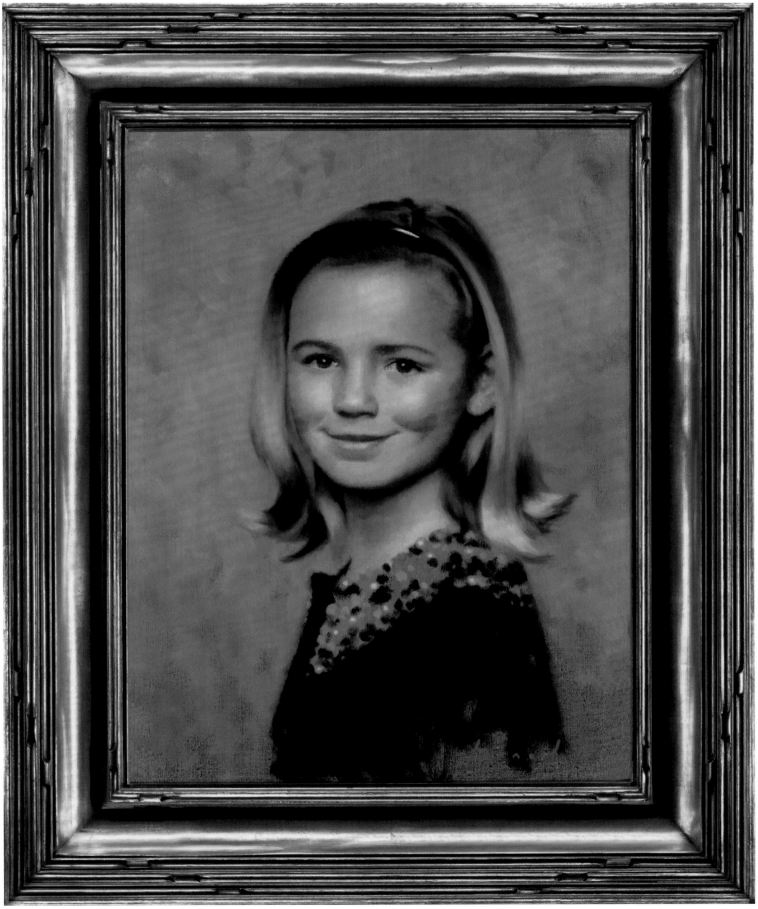

Step 5 The painting now finished, is framed, installed, and lit.

Isabel, Oil, 14.5" x 12"

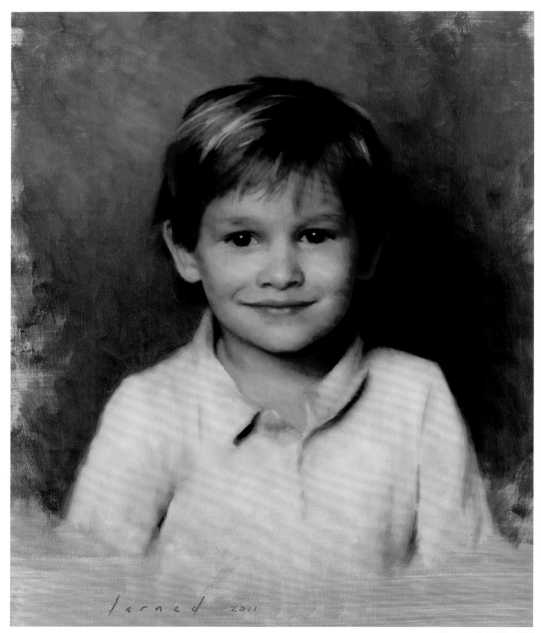

Rascal, Oil, 17" x 13"

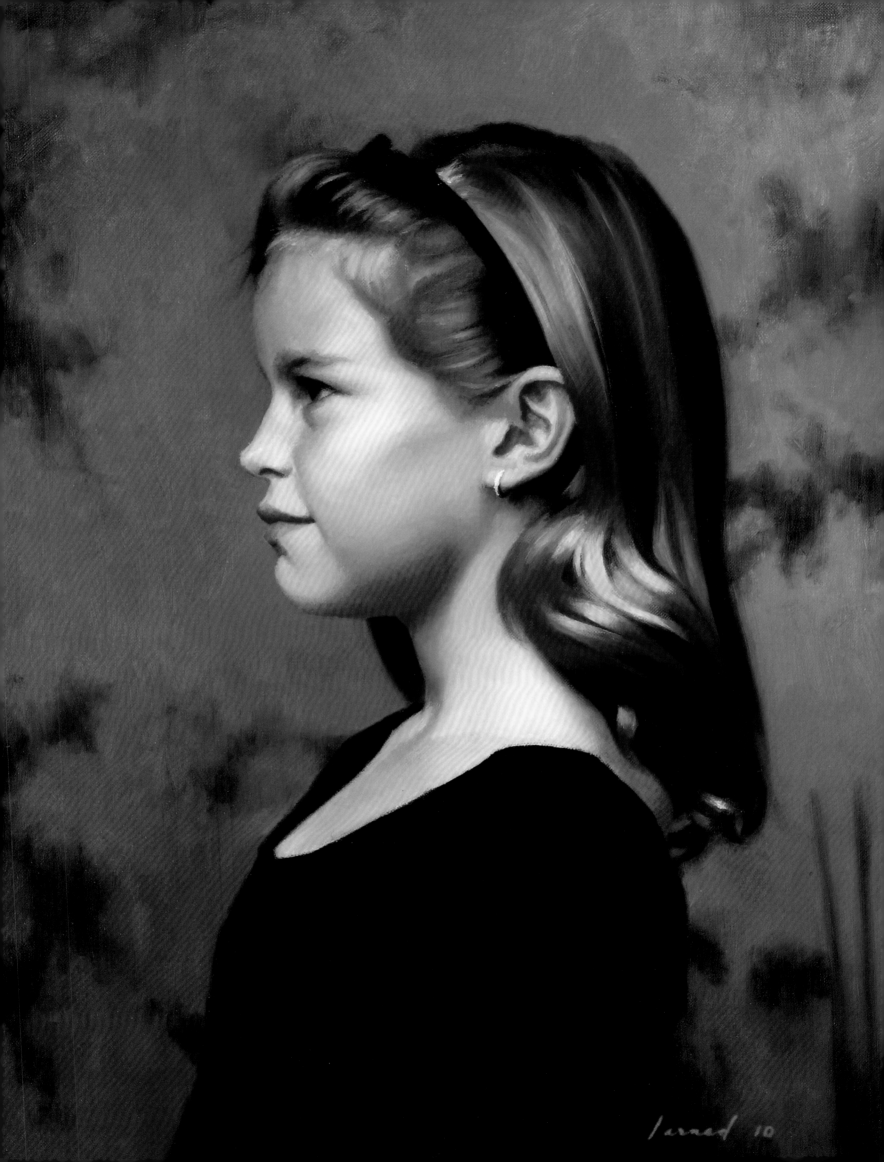

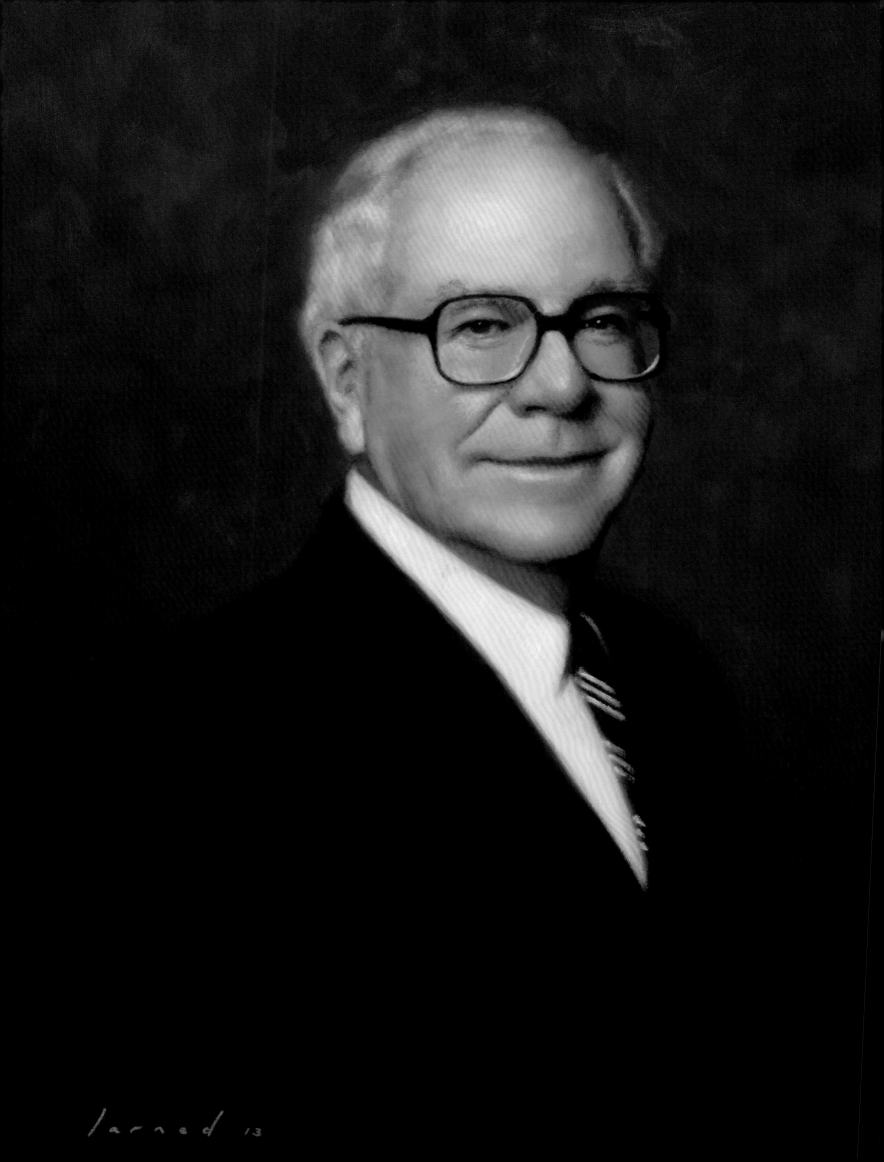

larned 13

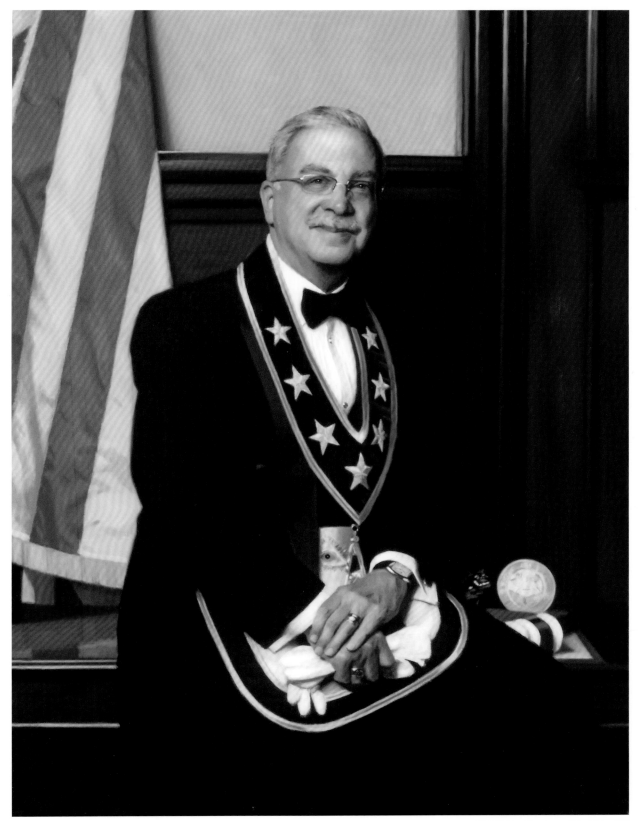

R.W.G.M., Gardner, Oil, 40" x 30"

"The aim of art is to represent not the outward appearance of things,
but their inward significance."

- Aristotle

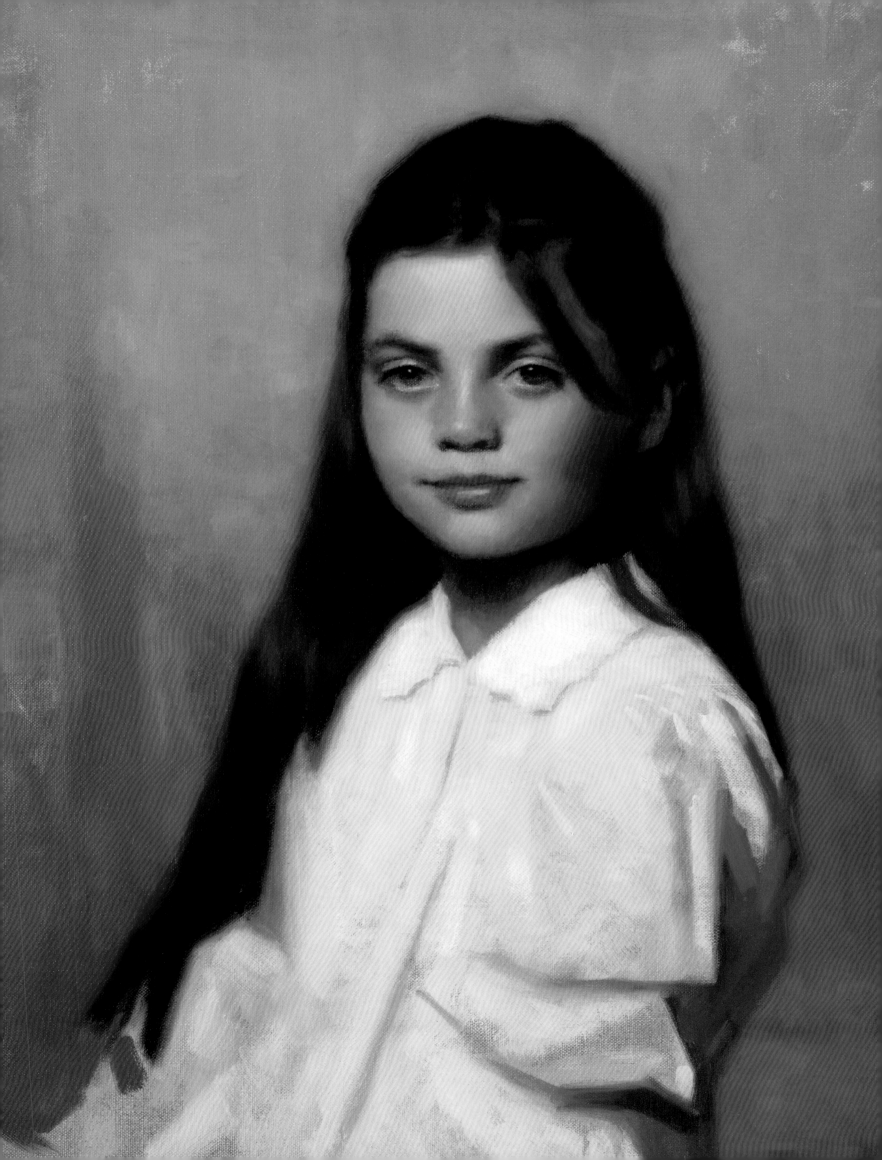

IN THE STUDIO

Studio life is monastic. Peaceful. There are no lights on. The only light comes from a large north-facing window. No computer, no phone. Sometimes music is my only company. The way I paint takes time. I will usually work for several weeks on one canvas. Sometimes longer. For lack of a better word, it is Zen. It's a place to focus and get lost in a project.

The studio itself is near West Chester, PA. The painting room is about 20' x 20' with tall ceilings and most importantly the high north-facing window. This light provides the most consistent and arguably most beautiful light. It is very soft, even, and silvery. This is the light Rembrandt and almost every other portrait painter has used over the centuries. The easel is set up directly next to my subject in the middle of the room. I pace back and forth from a fixed observation point to the canvas (about 10' away) all day long. I spend more time looking than painting. The art is in the observation. The actual application of paint is merely a response to what I decided was necessary from my observation point.

As for materials, painting is extremely and wonderfully low-tech. I use the same basic equipment that artists have since the Renaissance: hog's hair brushes, oil paint, linseed oil, turpentine, and Belgian linen. I have used the same wooden palette on every painting I have ever made. On it are ten colors. From those I can mix any tone I see in nature. The only somewhat modern tool I have is a camera. Artists have used them since the Daguerreotype was invented in 1836. Vermeer even used a primitive version called the camera obscura. I find the camera particularly useful when a subject can't sit due to time limitations or distance. In this case, I enlarge a print to "life" size and set it next to the canvas so it was as if he or she was actually modeling for the painting. This way, the painting process is virtually the same as if it was painted from life.

I usually only work on one painting at a time. I become completely engrossed in it. It becomes my life for a few weeks. Then I move on to a different life. The paintings affect my moods. There is excitement in the beginning, struggle in the middle as I work through the issues, and finally resolution and hopefully fulfillment in the end. It's a cycle that repeats itself with every project. Amazingly, every painting feels like the first one I ever painted. No two are painted alike. I am always modifying my approach and solving different problems in new ways. It is endlessly engaging. The studio is home to intellectual creativity and material creativity—continually giving birth to new paintings.

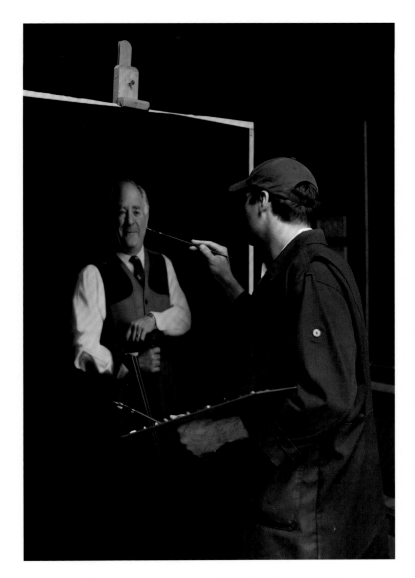

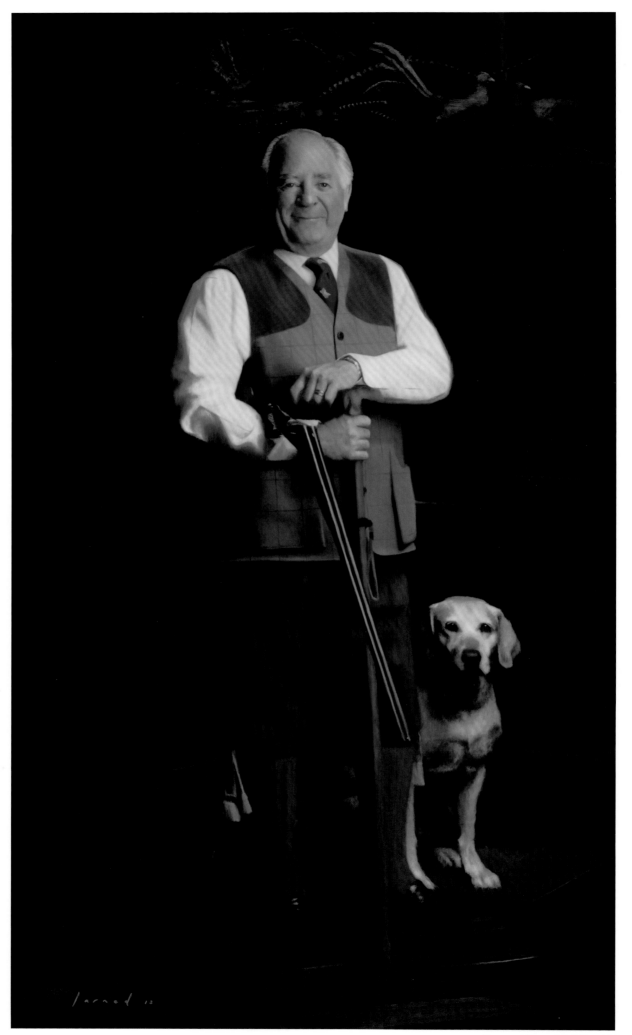

Dan and Riley, Oil, 80" x 46"

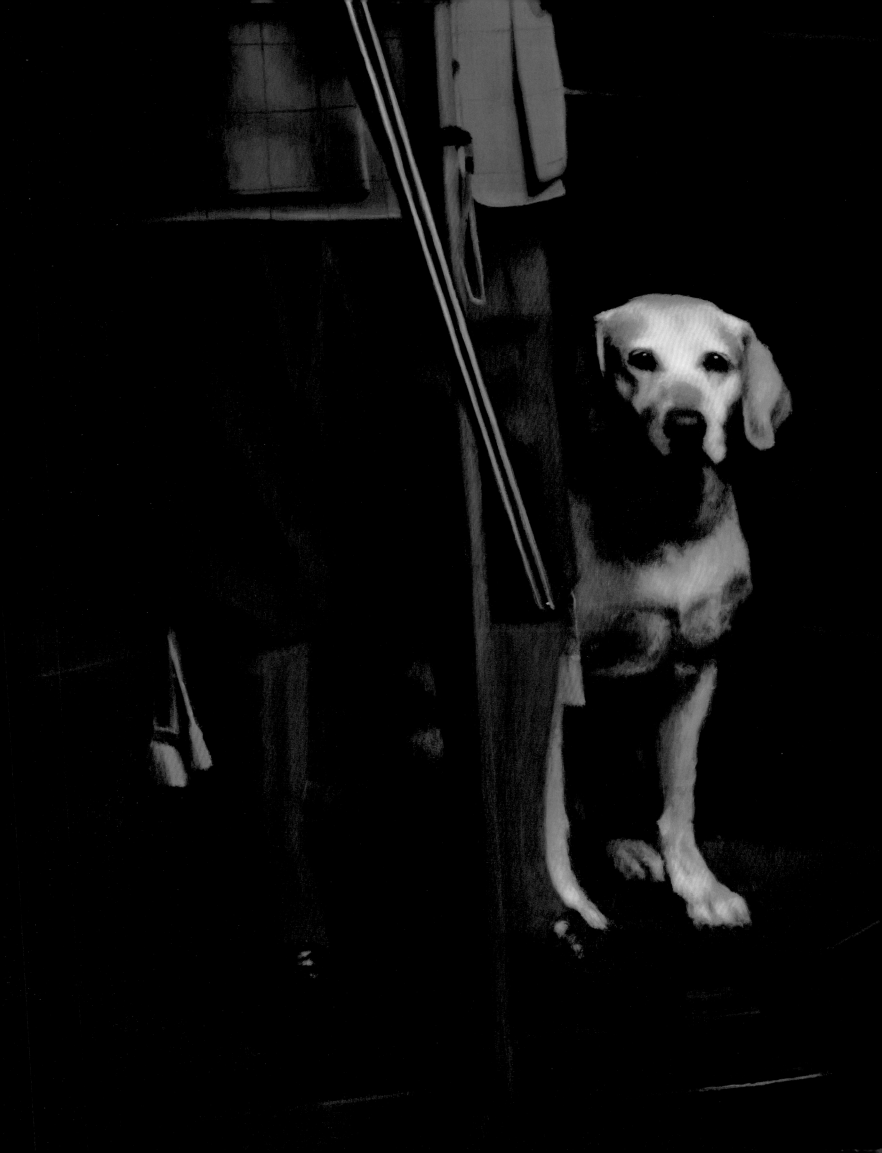

The Art Collector, Detail

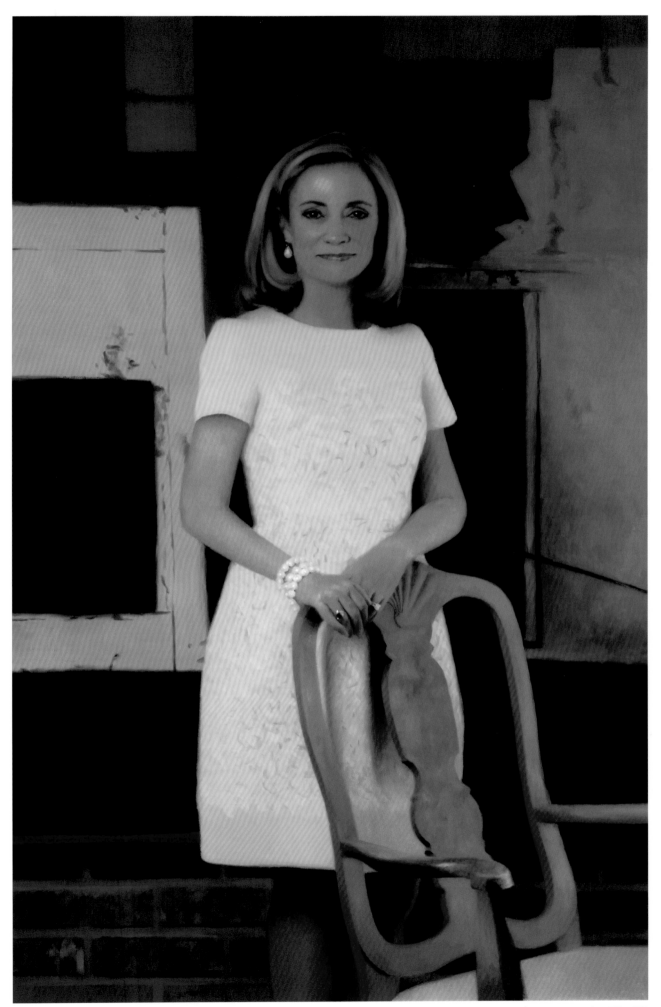

The Art Collector, Oil, 53" x 33"

"What beauty is, I know not,
though it adheres to many things."

- Albrecht Dürer

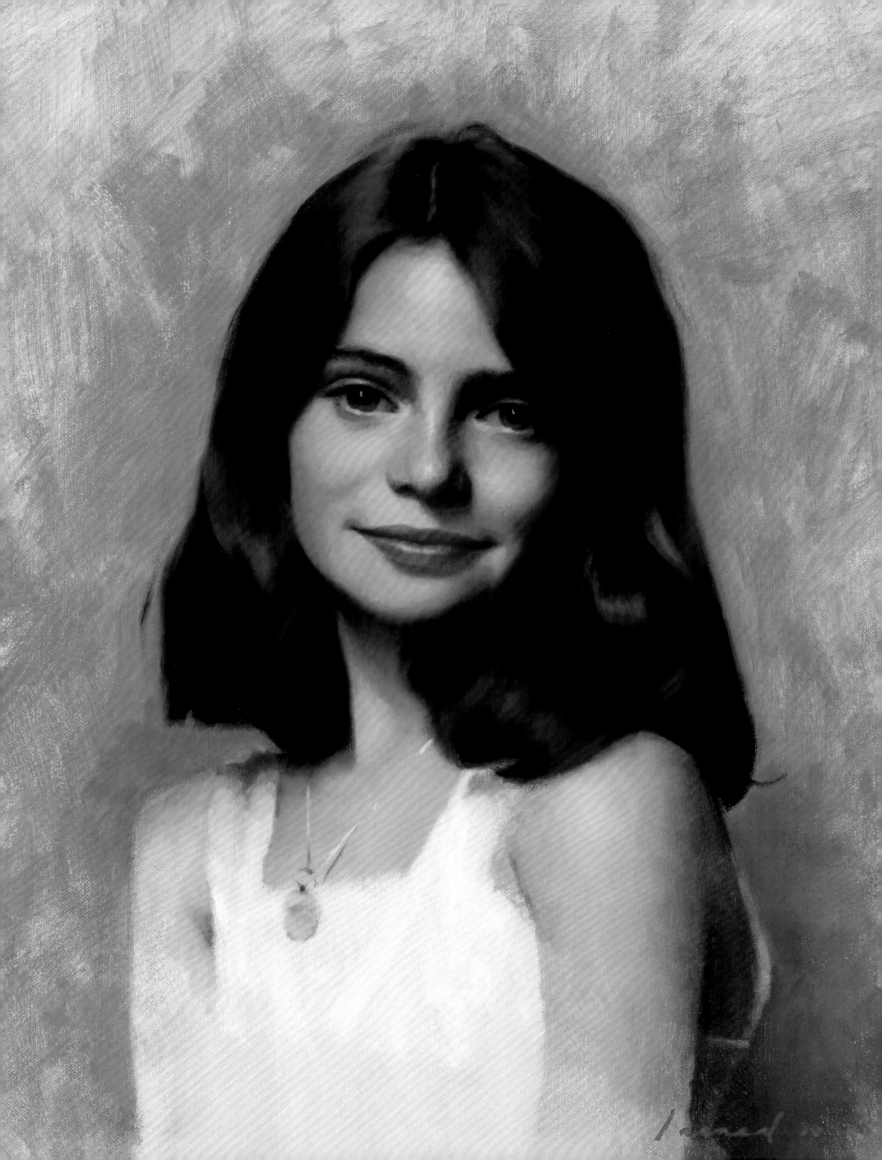

"An artist's only concern is to shoot for some kind of perfection,
and on his own terms, not anyone else's."

SEARCHING FOR SIMPLICITY

Style is perhaps the hardest aspect of painting for an artist to explain. Style is innate. It may be informed by history and influenced by current trends, but these only help shape one's own fundamental, self-defining, inner sense of style. It would be difficult, maybe impossible, to teach style. Feel reigns over reason. I have always been attracted to clean, elegant design. The simple solution is the beautiful one. To paraphrase Sargent, "Finish is more about removing unnecessary things rather than adding more." A strong, unified, and interesting composition is the bedrock from which all great paintings stand. The actual "look" of my work is a direct response to nature. I paint what I see. You get to truth (and therefore beauty) by being a diligent, quiet observer, not by imposing your artistic will on the subject. If there were a painterly standard to hold my work up to, it would be the European painters from the late 19th century. However, to be relevant, one must also be very much of today. These are the poles that I vacillate between.

J.D. Salinger

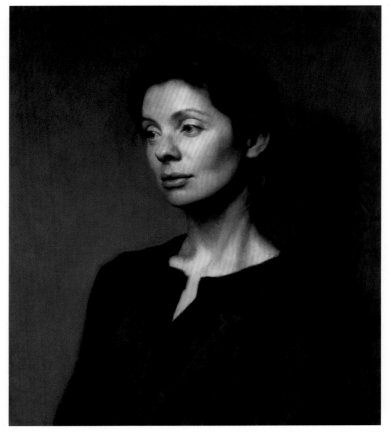

Tessa, Oil, 22" x 19"

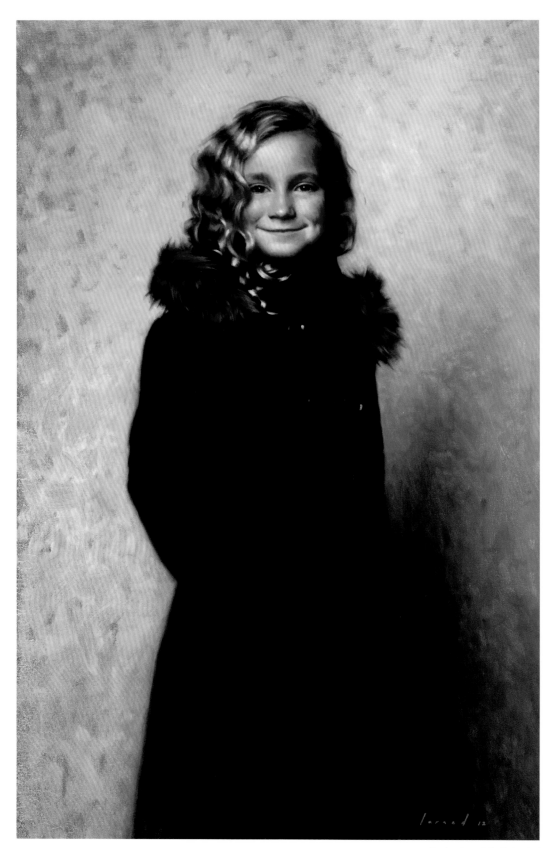

Catherine, Oil, 34" x 21"

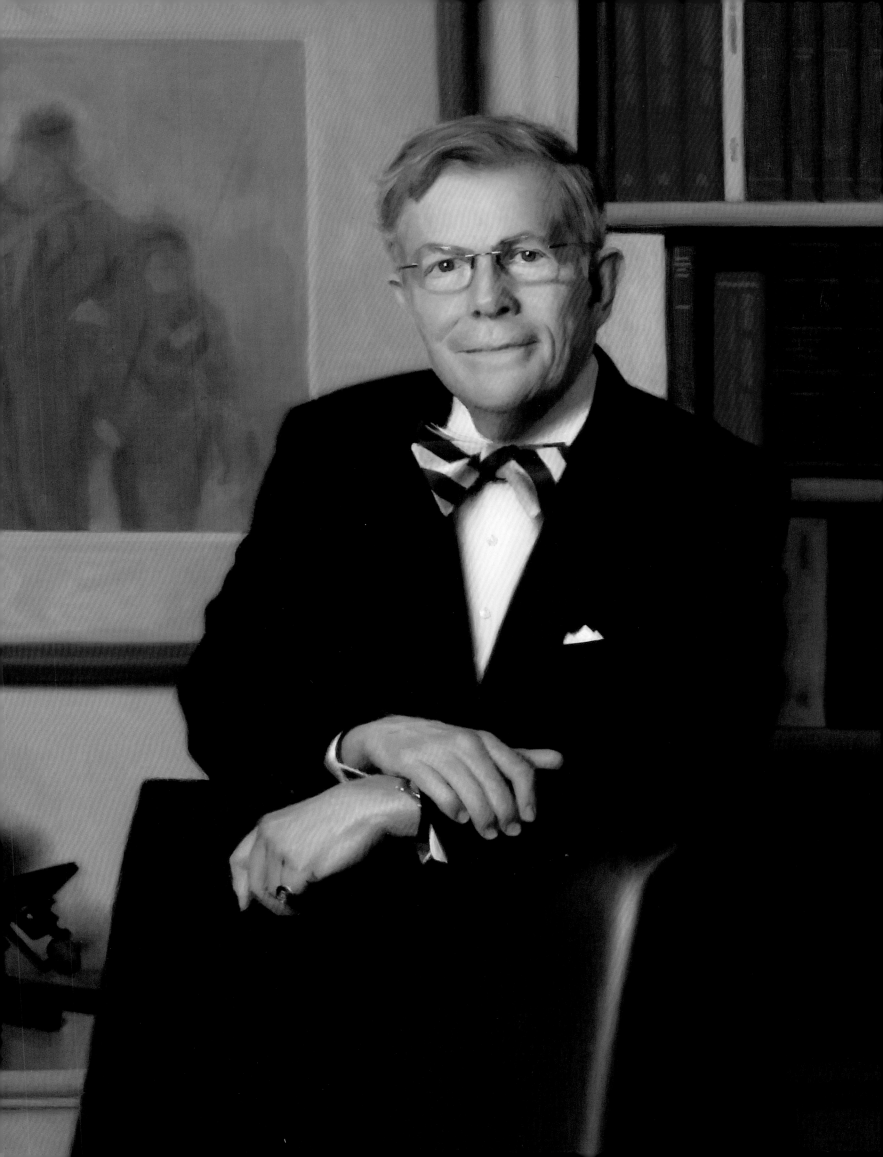

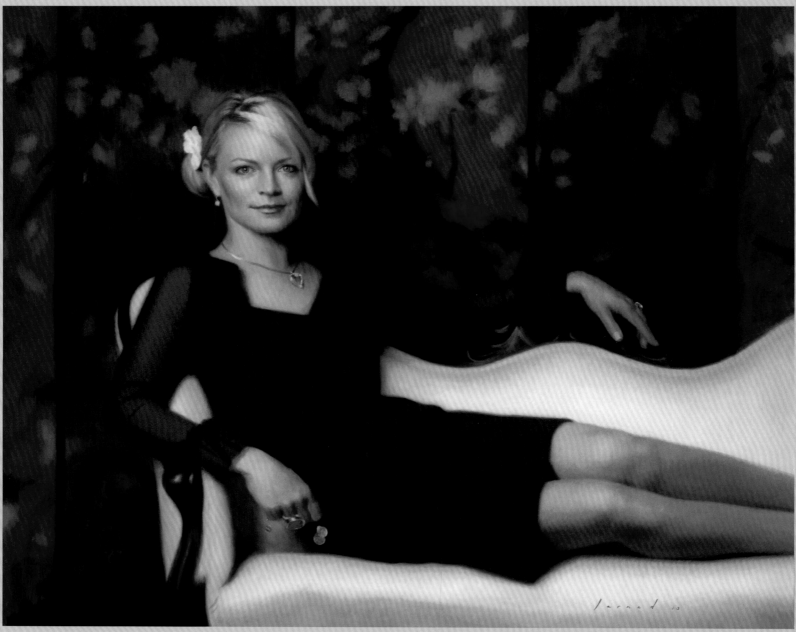

Kirstie, Oil, 33" x 41"

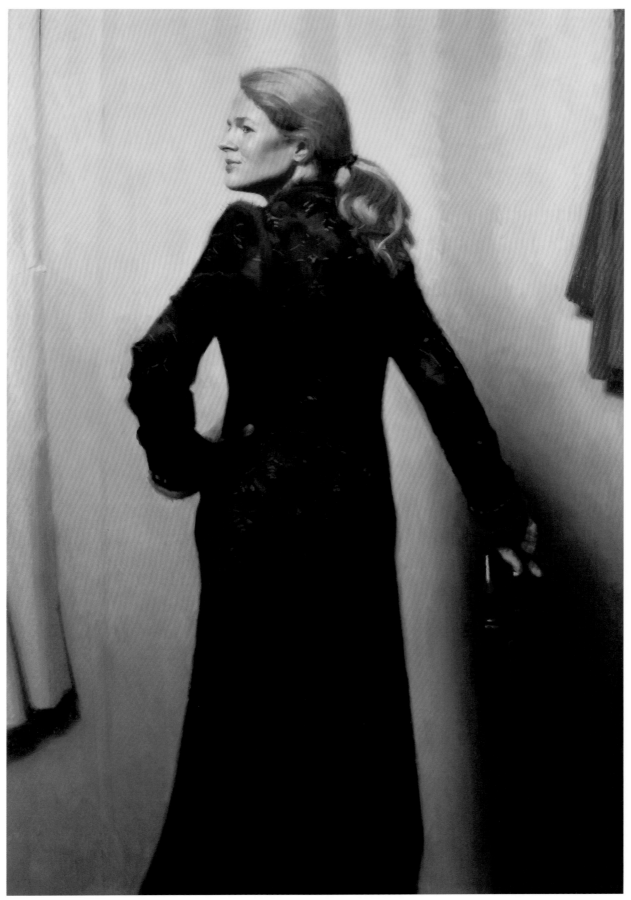

June, Oil, 66" x 44"

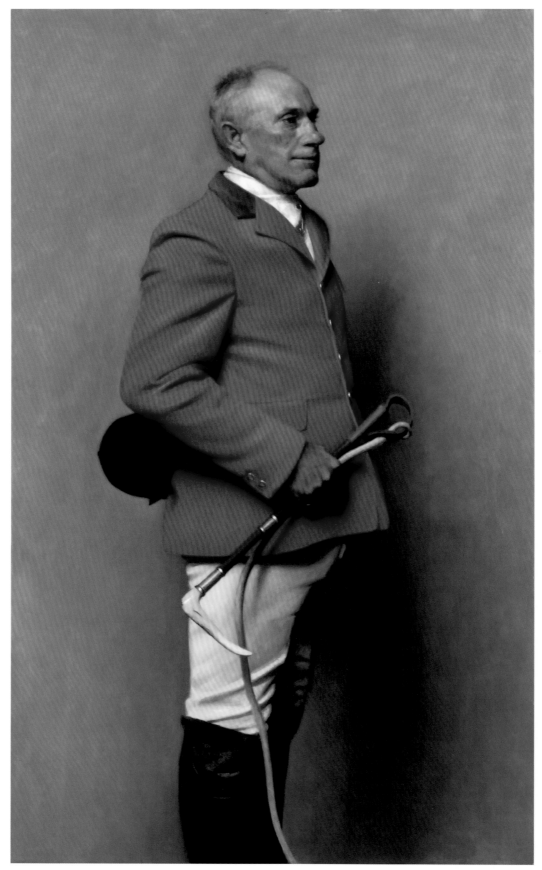

Master of the Hunt, Oil, 54" x 32"

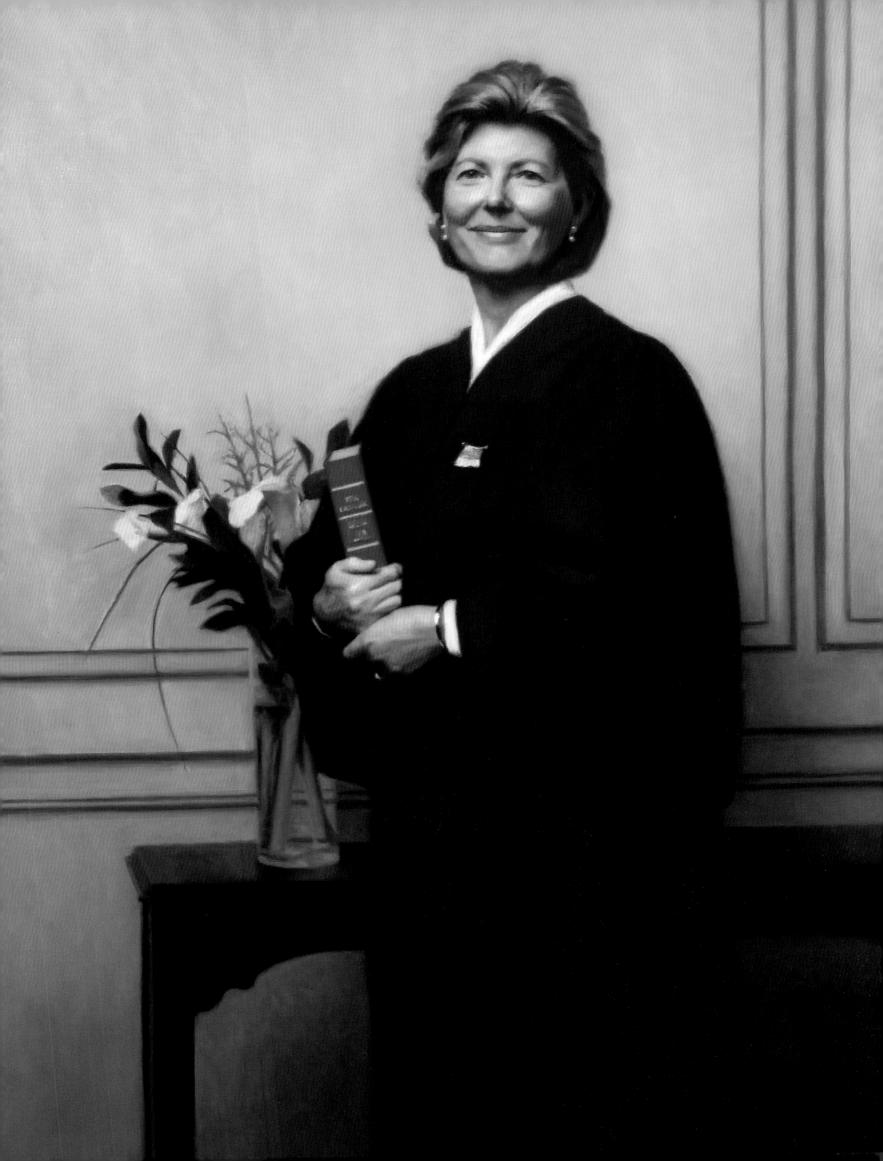

"Art is not what you see, but what you make others see."

COMPOSING IS ART

There is nothing more exciting to a painter than composing. It's a hopeful rush born from creating a new design on a new canvas. Composing is art at its most primal. "Where should this go and how large should it be? How many of these and how should they arc through space? Would it be better if this light form overlapped that dark one?" You don't really know why the hand should go here or the chair there, but you are correct—aesthetically speaking. It is at this point that you are reminded why you are a painter. You begin speaking a language that you have known before you knew you had it. Composing, like one's style, is not something that can be taught. It is supremely intuitive and personal.

Edgar Degas

Technically when painters compose, they are arranging the dominant pattern of lights and darks. These pieces should lock together in a simple yet interesting way. Without this strong, underlying abstract design, no matter how well painted a head may be, the overall effect of the painting will suffer. This most basic, overall design is what draws you across a room to inspect a painting further. It's not the details of the model's hair but the overall way she relates to the canvas itself that makes a painting compelling from afar. One can learn why a composition works, but when composing, you are going on feel and can analyze why it is or isn't successful later. You don't push something closer to the edge of the canvas or crop down on something else because precedent tells you to. You do it because it feels better.

The most interesting compositions are balanced yet have rhythm, often an asymmetric one. It should feel natural yet be engaging. Anything obviously composed has been pushed too far. A good composition also establishes a hierarchy of importance. The overall design must be pleasing from afar but upon closer inspection have each component part in its subordinate place. For instance, after the overall design is recognized, the head should be perceived before the body, the body before the background, and so on. If all of this is orchestrated properly, the viewer is inexplicably drawn to the picture and enchanted by its design. The artist has succeeded in making the viewer feel what attracted him to the subject in the first place.

PICTURED ON LEFT:
Catesby Clay
Oil, 50" x 36"

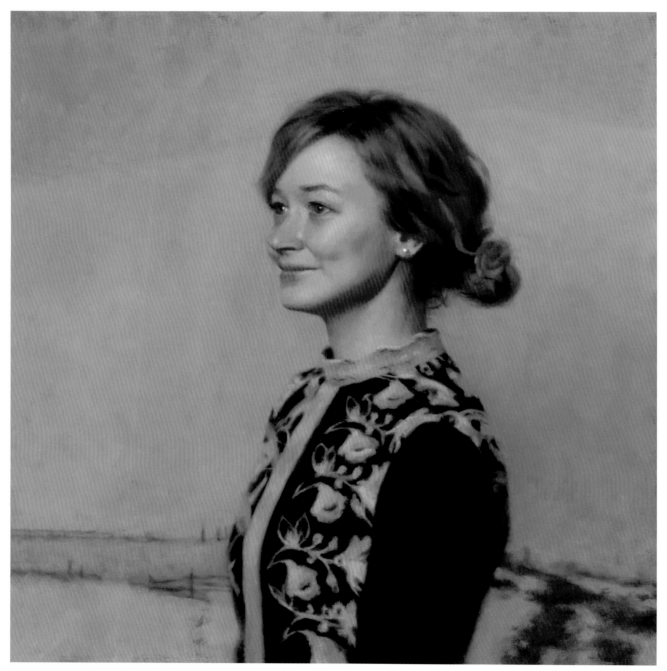

Annie's Dress, Oil, 23" x 22"

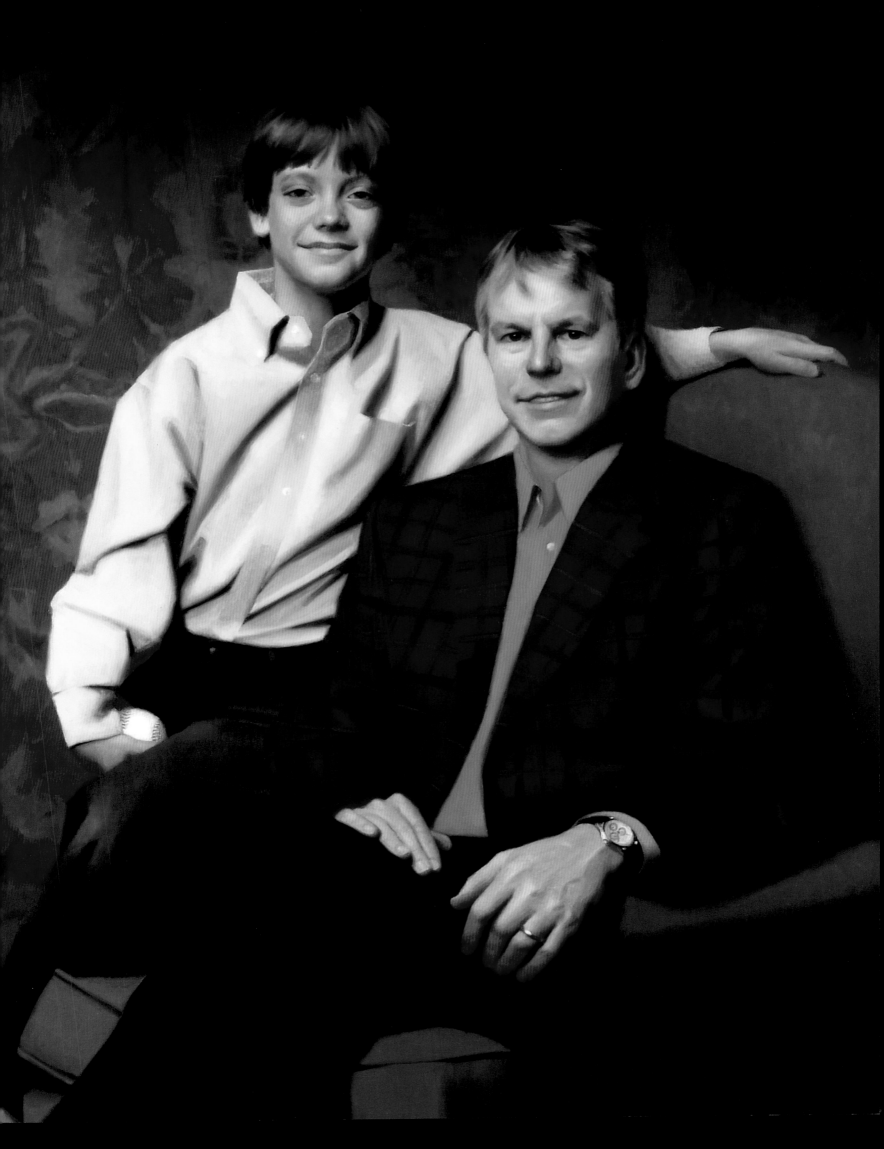

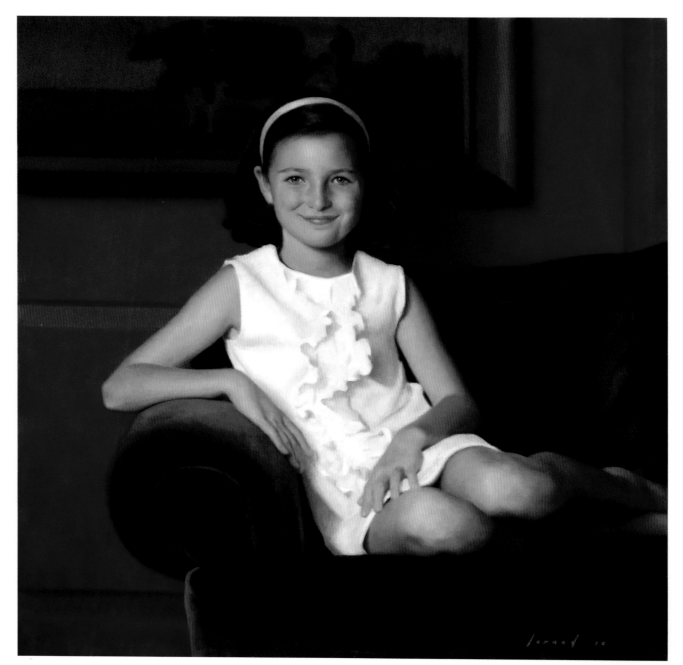

Peyton, Oil, 31" x 30"

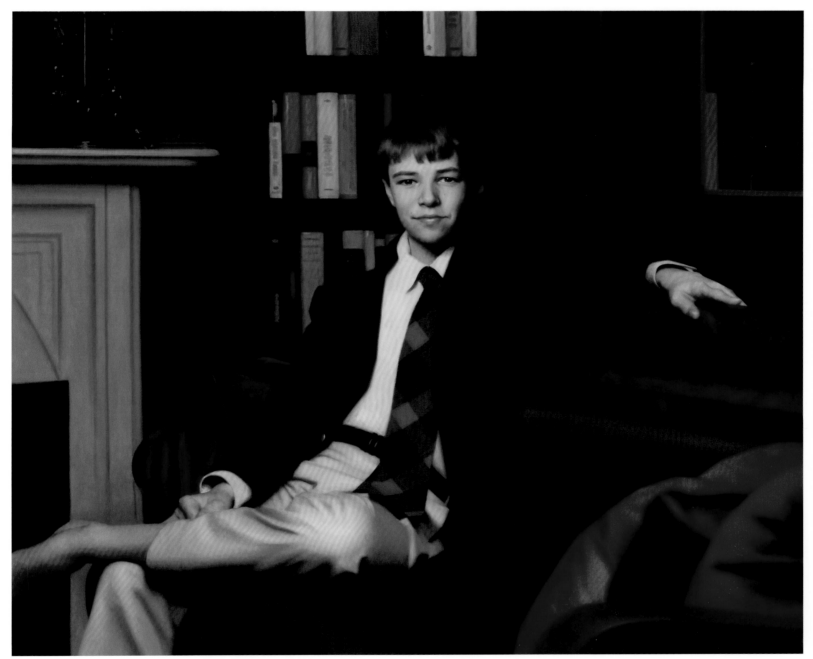

Charles, Oil, 42" x 31"

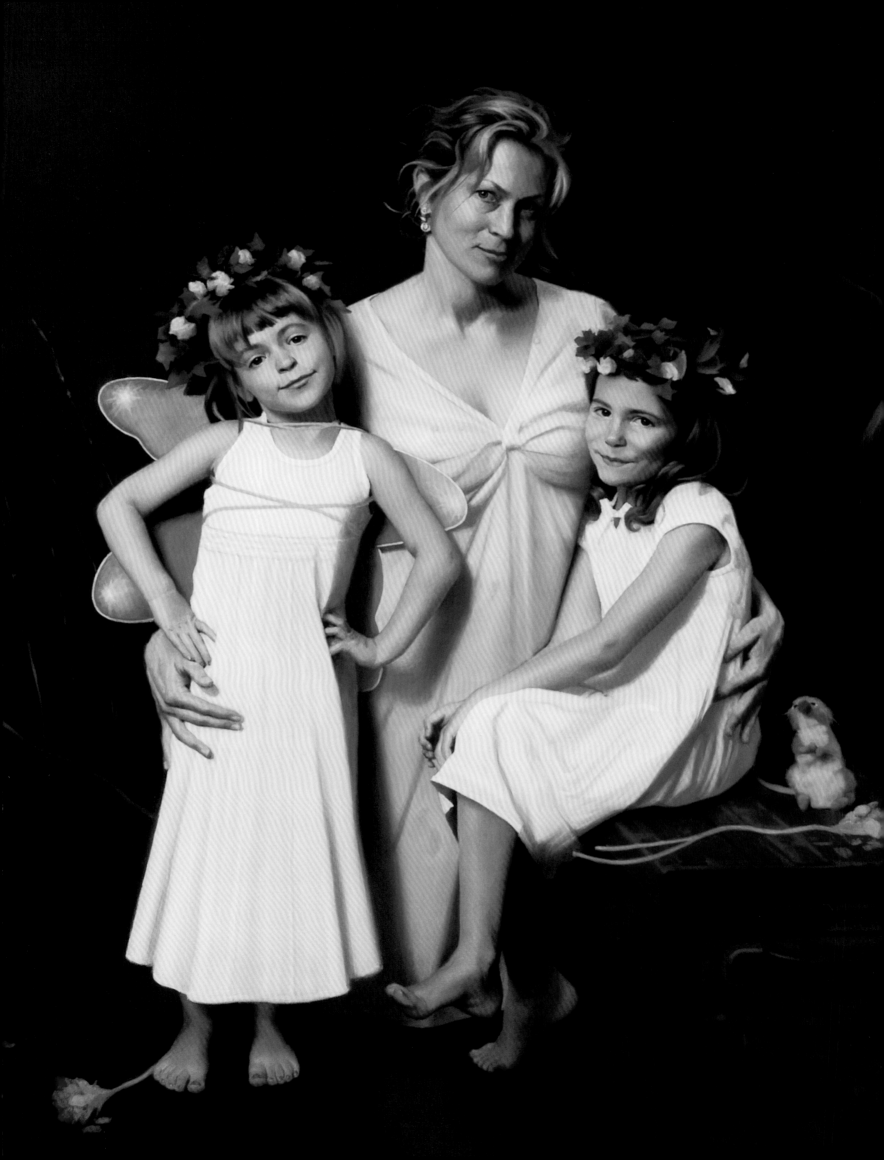

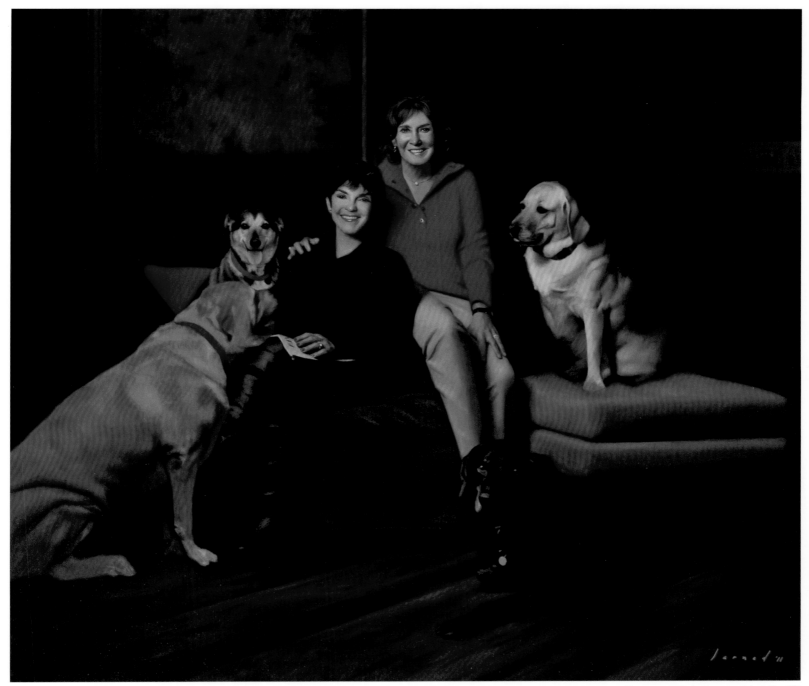

Dogs and Their People, Oil, 64" x 72"

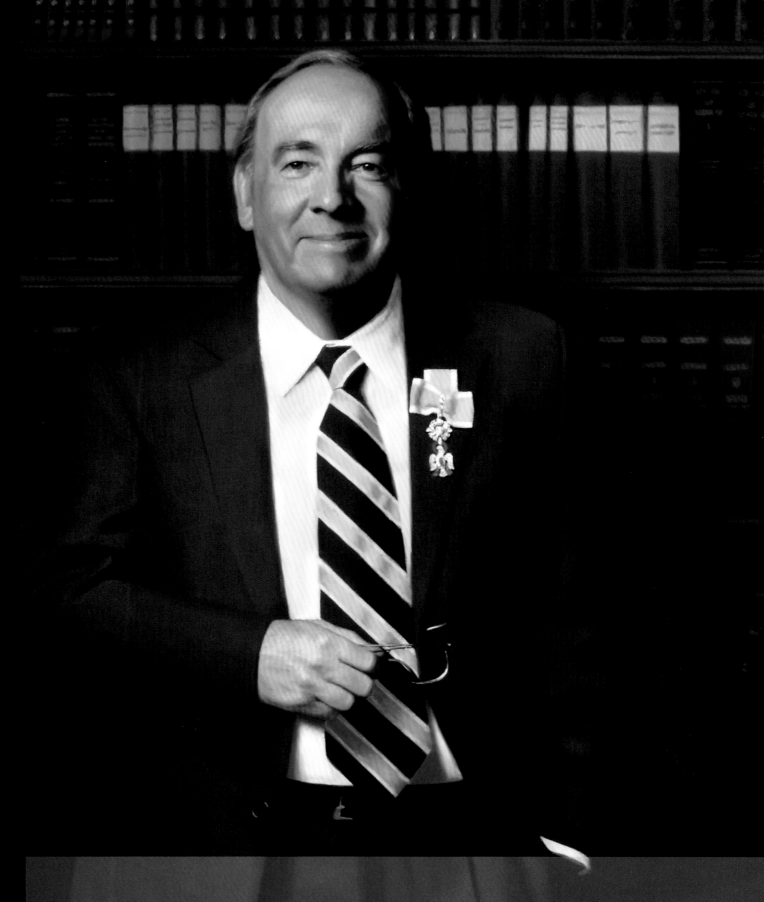

There is no definition of beauty, but when you can see someone's spirit coming through, something unexplainable, that's beautiful to me.

REVEALING CHARACTER

A portrait is a collaboration. Subject and artist create a painting together. The subjects provide inspiration, and the artist, through visual perception, technical skill, and human sensitivity, paints them how they appear. Beyond a likeness though, a great portrait should strive to capture the sitter's essence. Some subjects immediately reveal more of themselves than others. Other personalities are more layered or hidden. The artist has a variety of tools to draw character out while staying faithful to the subject. Everything from adjusting the lighting and expression to changing the background, clothes, and pose affect how character is perceived. Ideally, the finished painting not only looks like the subjects but feels like them too. I try to let the subject's personality do the speaking. By making my own artistic hand invisible, it allows the canvas to become suffused with the sitter's character. Ultimately, it enlivens the paintings, making them "real"—as if they could walk out and speak to the viewer.

Liv Tyler

PICTURED ON LEFT:
The Society of the Cincinnati, President General, George Forrest Pragoff
Oil, 44" x 32"

PICTURED ON RIGHT:
The Green Coat
Oil, 37.25" x 27.25"

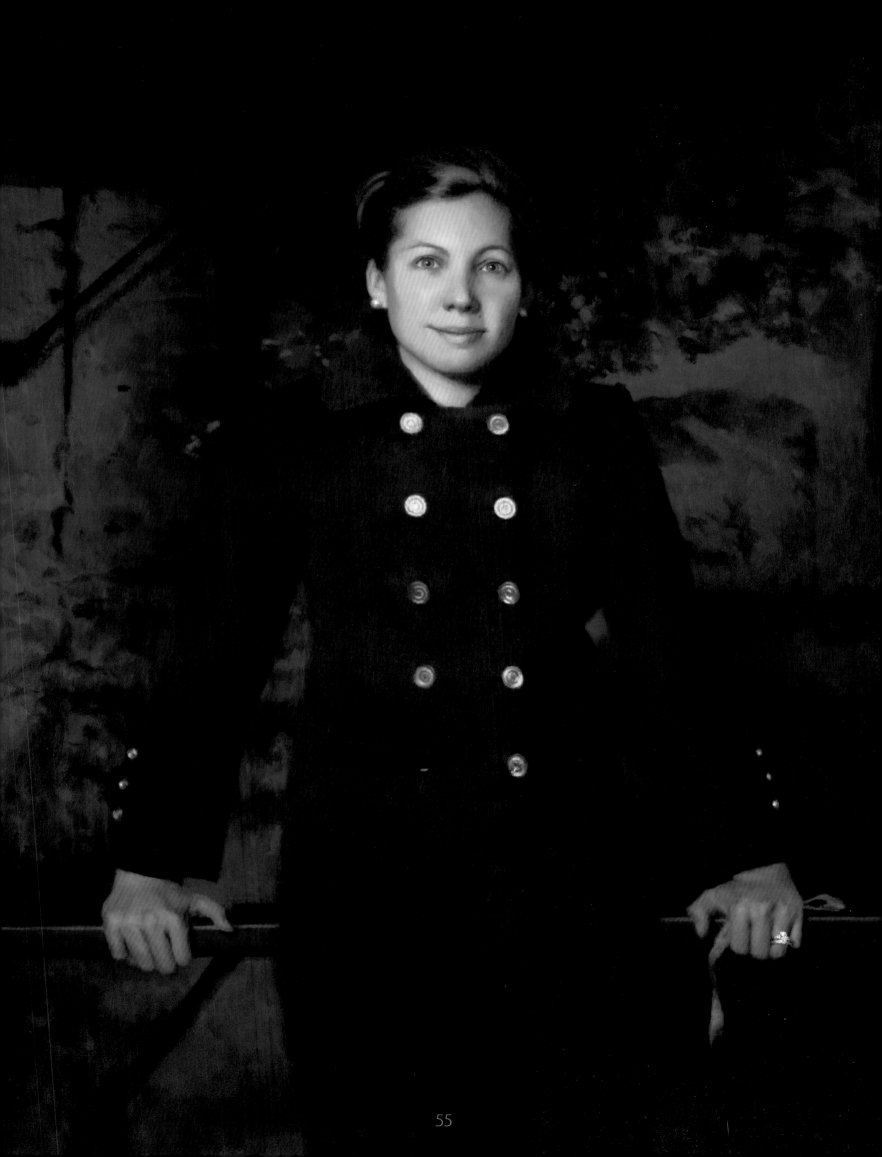

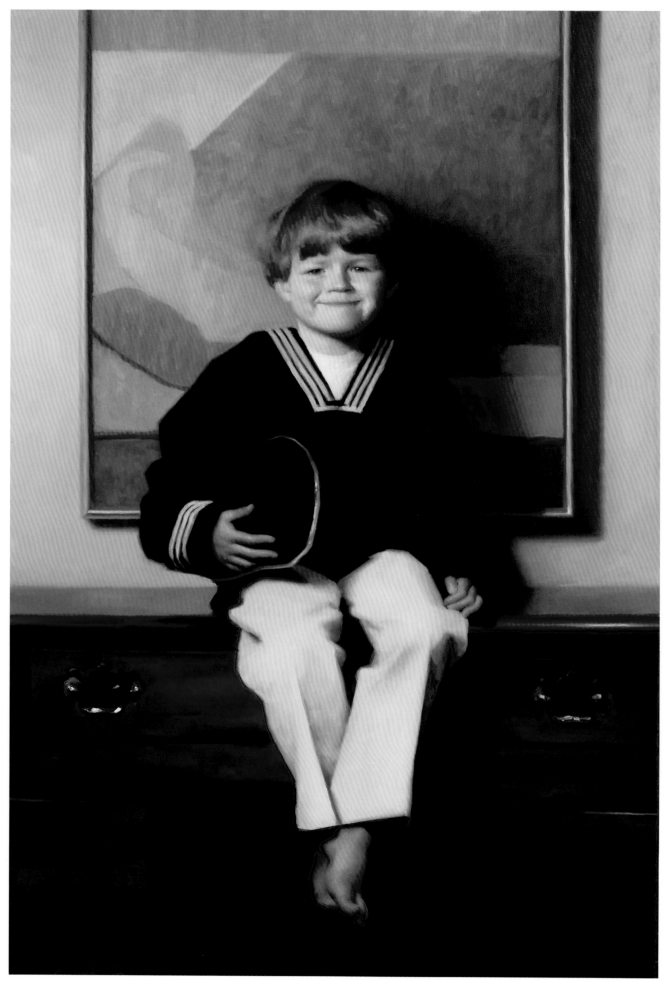

Marshall, Oil, 46" x 30"

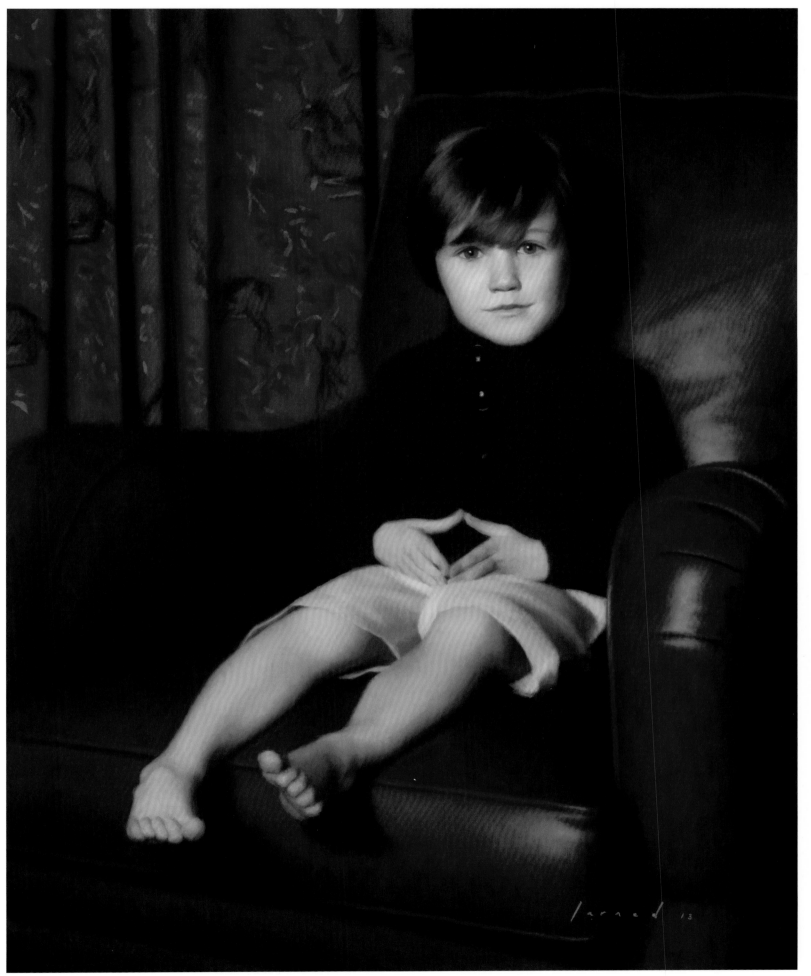

Grady, Oil, 33" x 26"

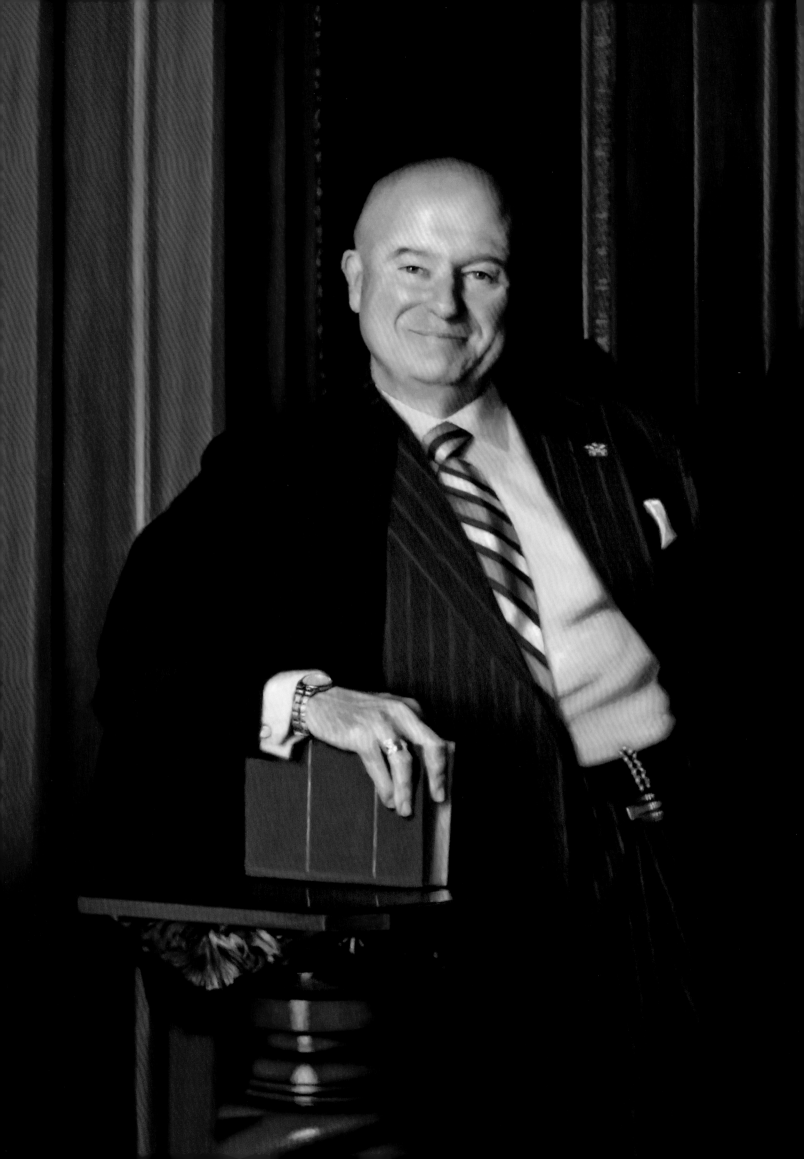

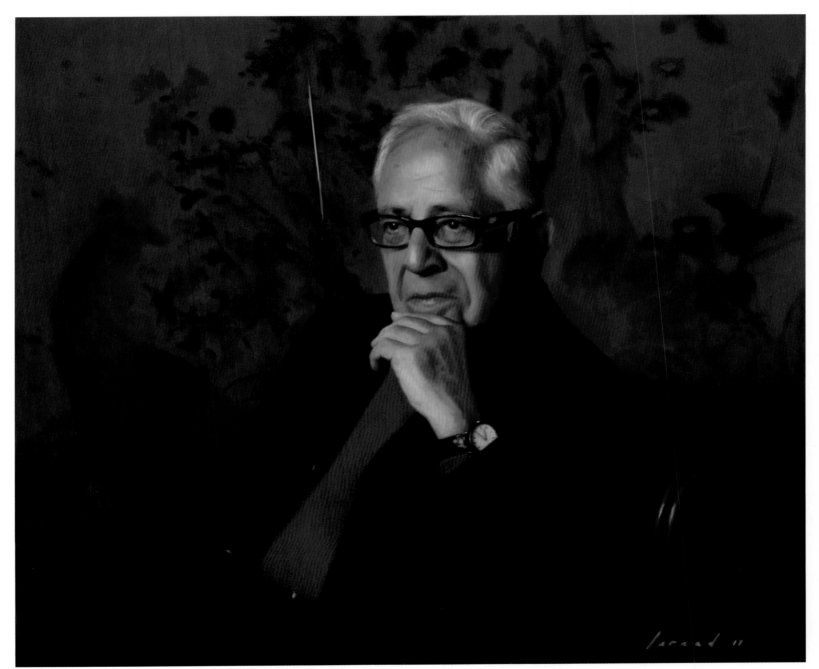

Curtis Institute of Music, President Gary Graffman, Oil, 25" x 29"

Supreme Court of Pennsylvania,
The Honorable Seamus P. McCaffery
Oil, 40" x 33"

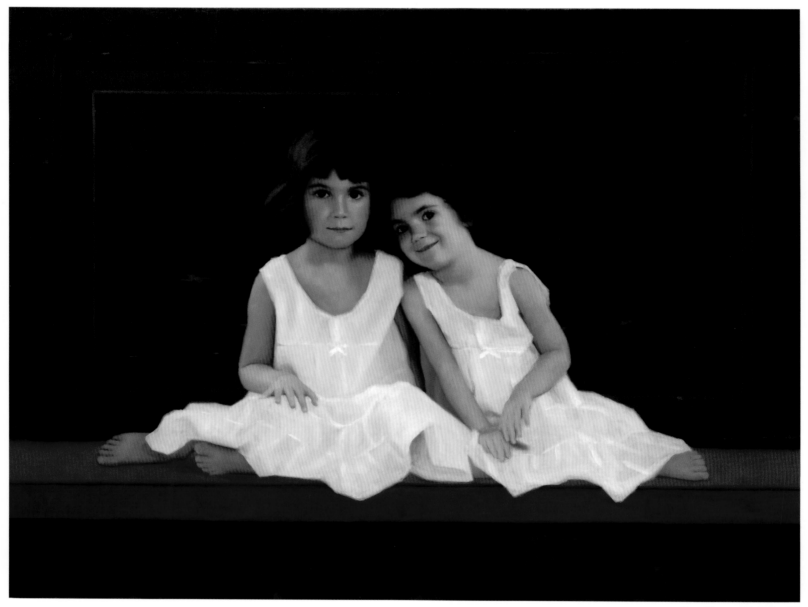

Two Sisters, Oil, 33" x 26"

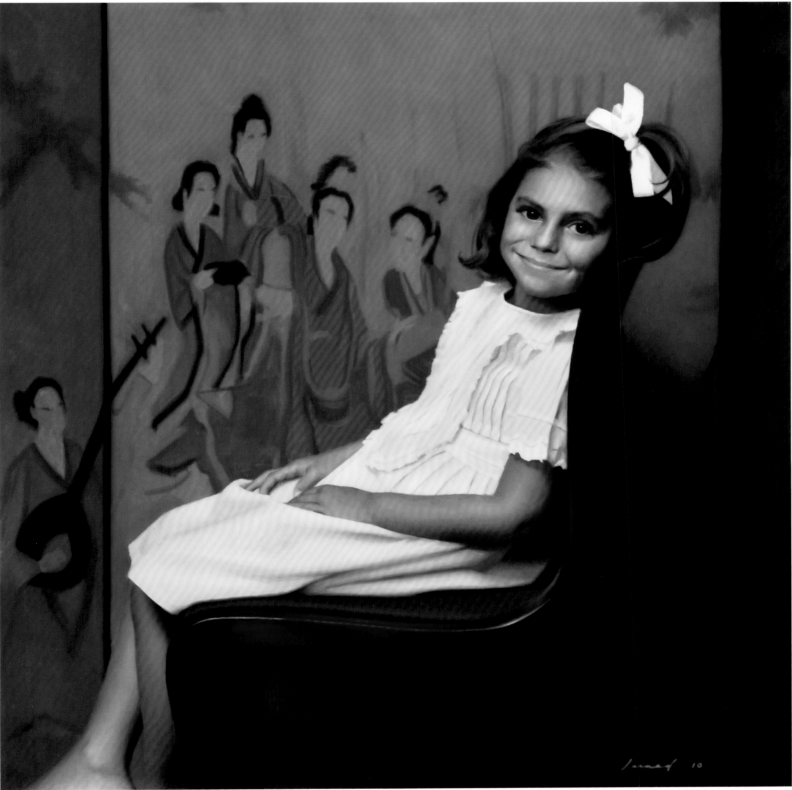

Claudina, Oil, 32" x 30"

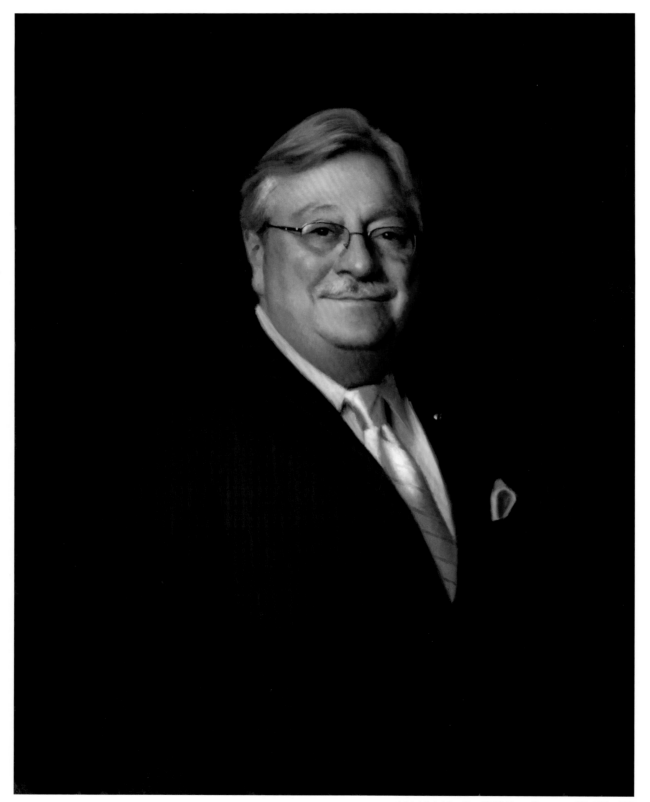

AAA Mid-Atlantic, CEO Don Gagnon, Oil, 32" x 30"

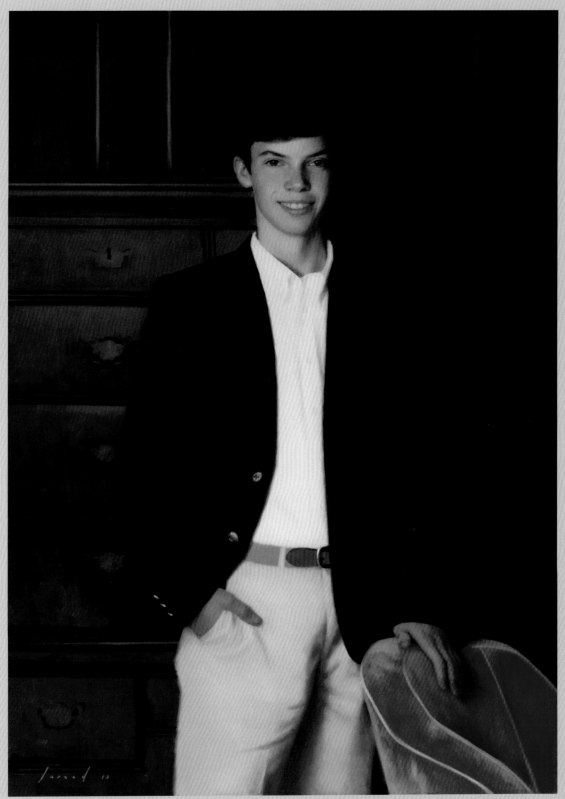

Henry Hamilton, Oil, 44" x 30"

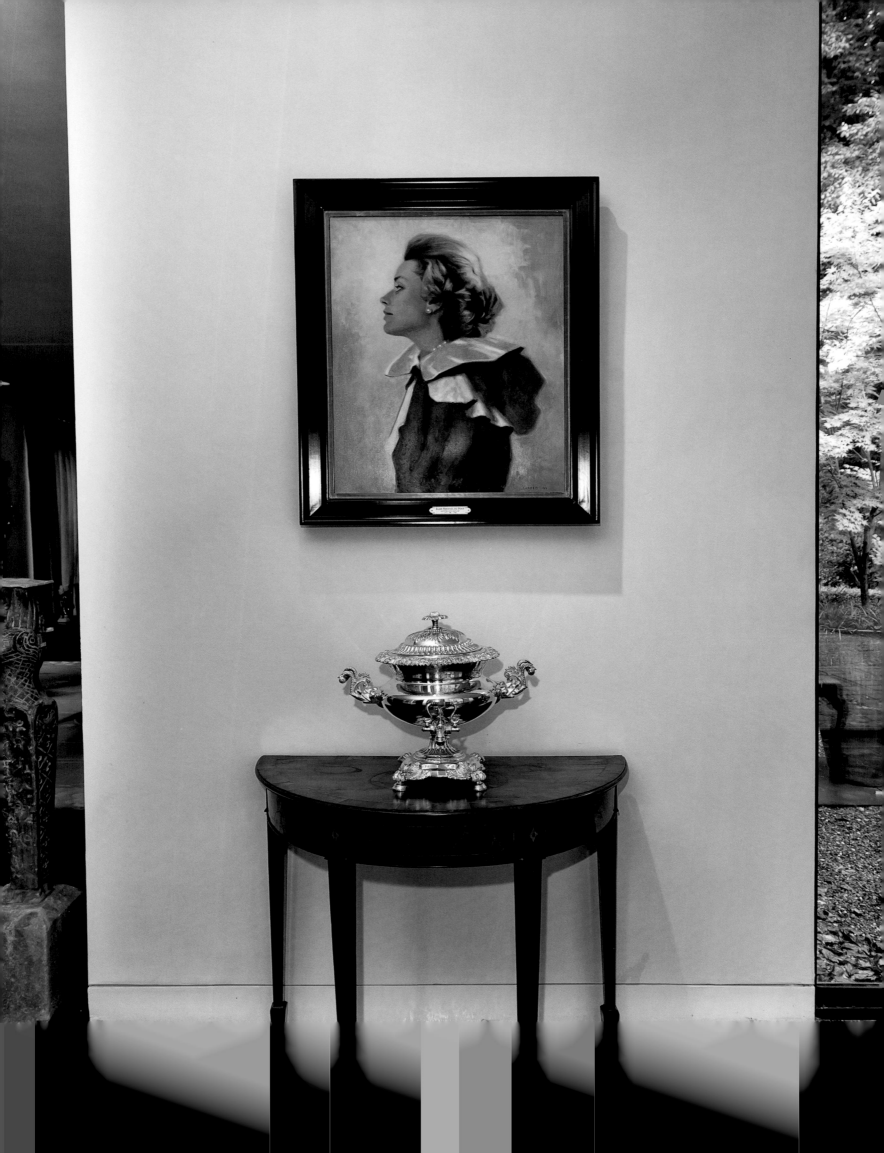

IN THEIR ENVIRONMENT

Excepting in the church, art has primarily been intended for domestic spaces. Portraits, more than any other genre of painting, are literally linked to the environment in which they are seen. A portrait in a living room is a tribute to the subject's importance within that family, just as a portrait of a founder of a company celebrates his or her contribution to that enterprise. A portrait brings meaning to a space, transforming a wall into a story about the people who live there, lending gravitas and emotional depth to the home. The paintings, beyond being decorative works of art, ultimately become a kind of visual heirloom being passed down through the generations, elegantly tying the past to the present, illustrating where a family has been, and defining who they are. The paintings make a space more beautiful and also entirely unique to that family.

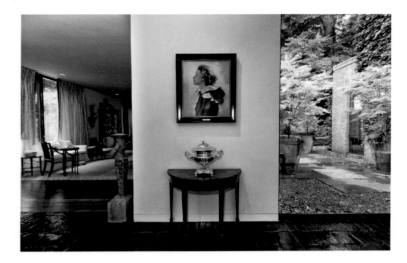

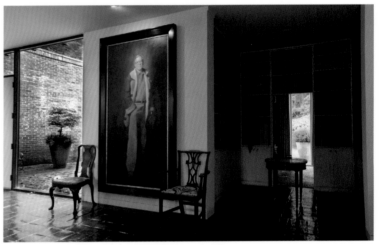

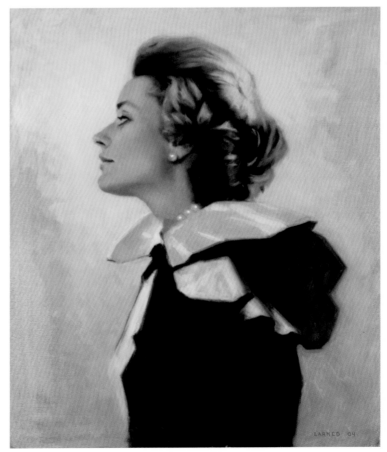

PICTURED ON LEFT:
*Governor and Mrs. Pierre S. du Pont IV Residence,
First Lady Elise Ravenel du Pont*

First Lady Elise Ravenel du Pont, Oil, 40" x 30"

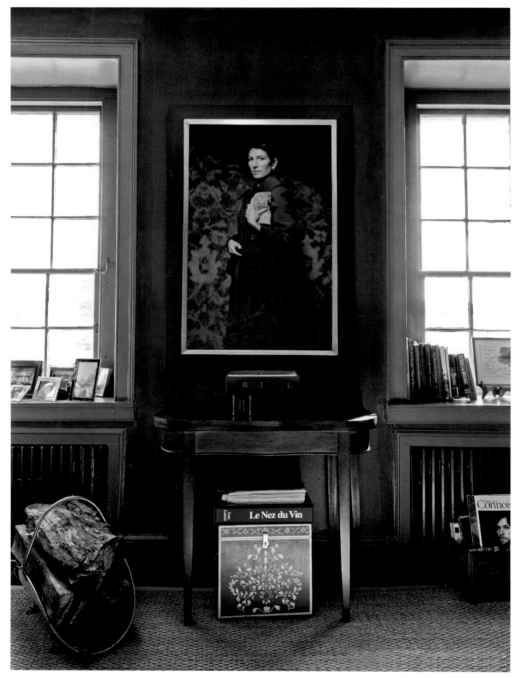

Mr. and Ms. Laird Bunch Residence, Tori

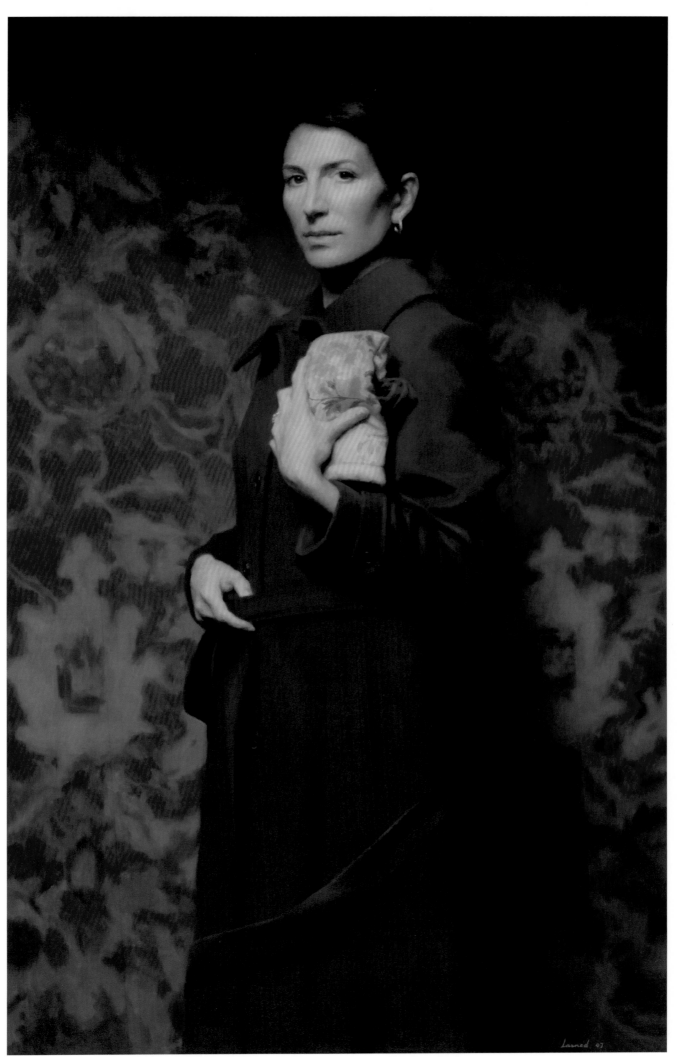

Tori, Oil, 44" x 27"

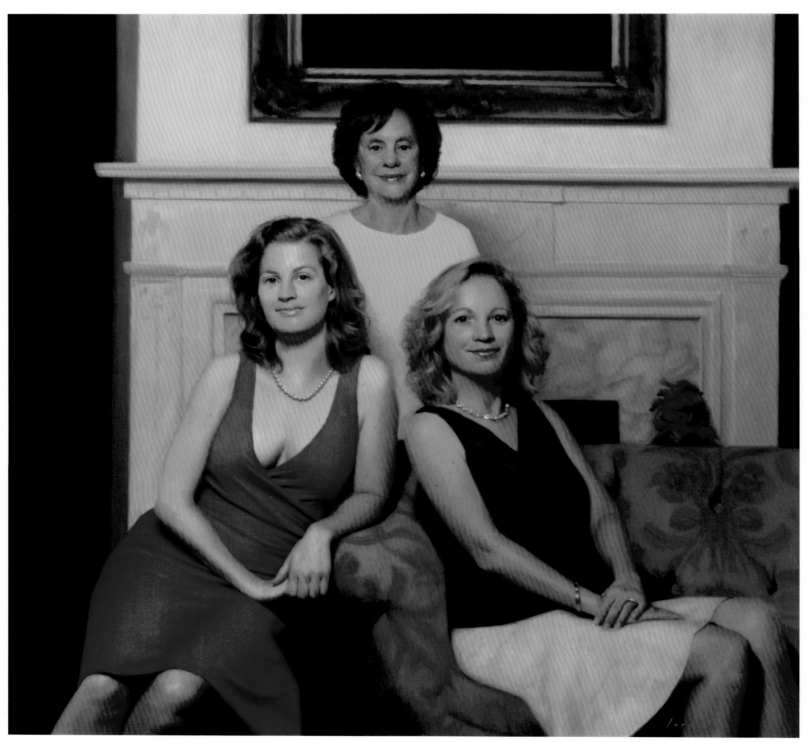

Three Generations, Oil, 42.625" x 45"

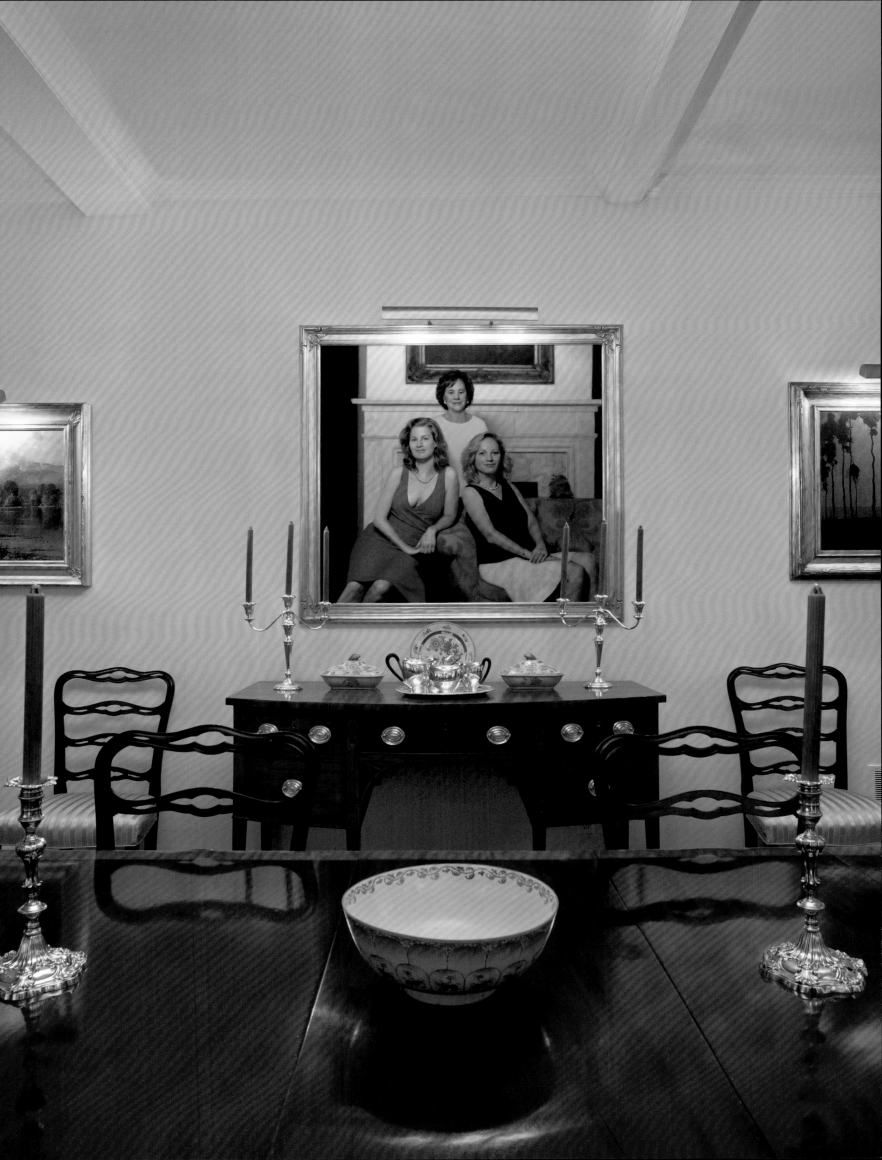

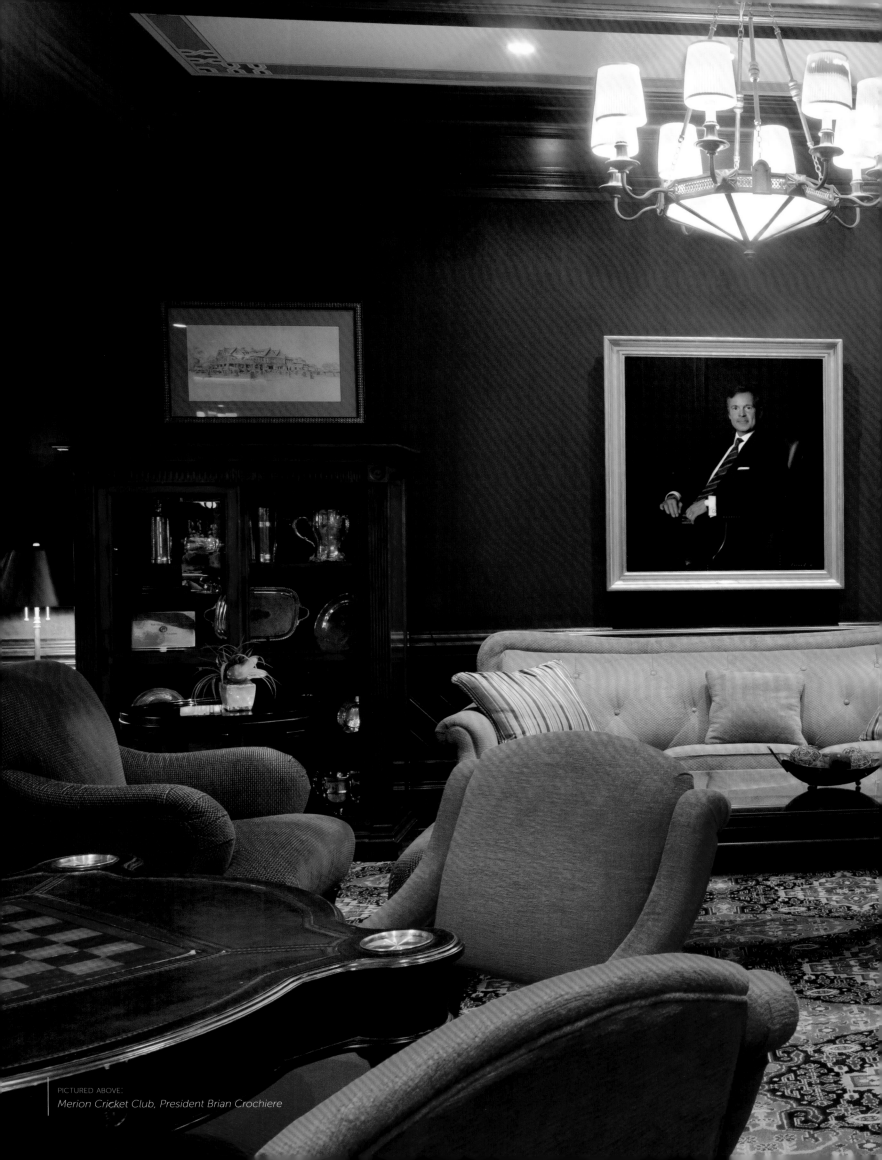

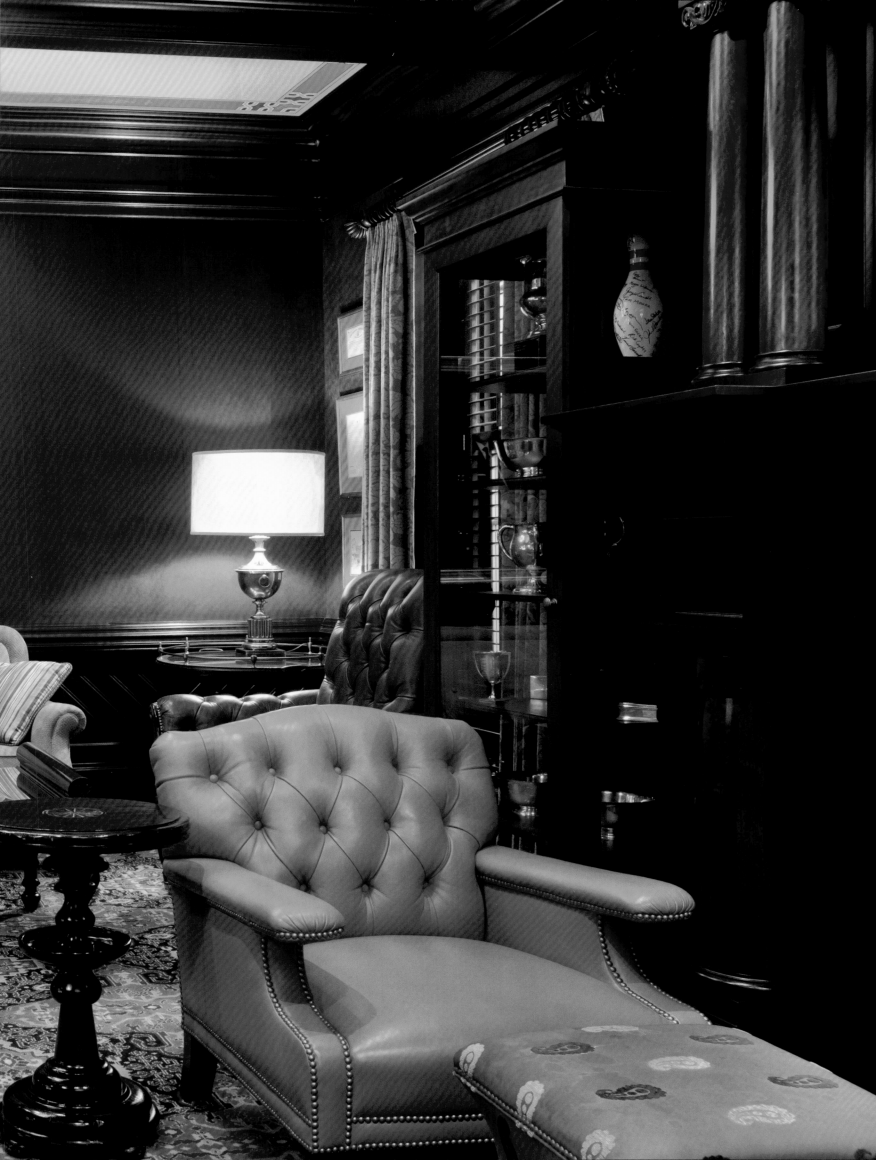

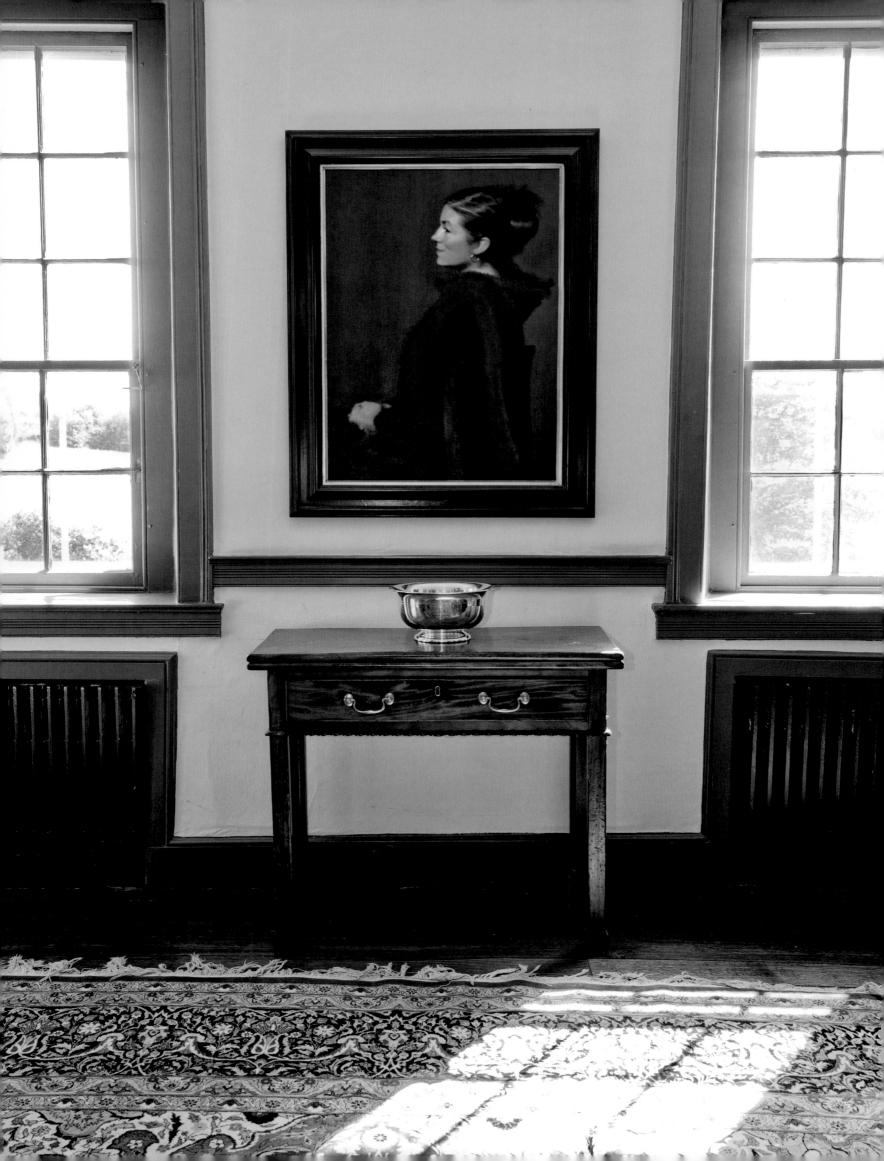

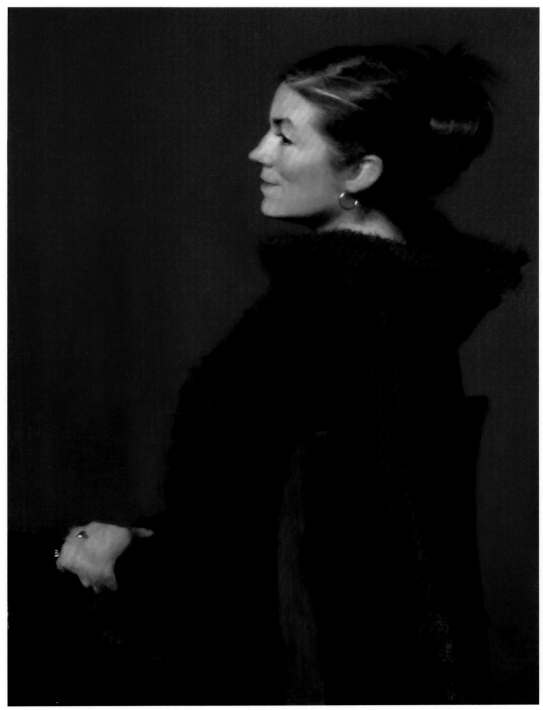

Sarah, Oil, 23" x 18"

Mr. and Mrs. David Larned Residence
Sarah

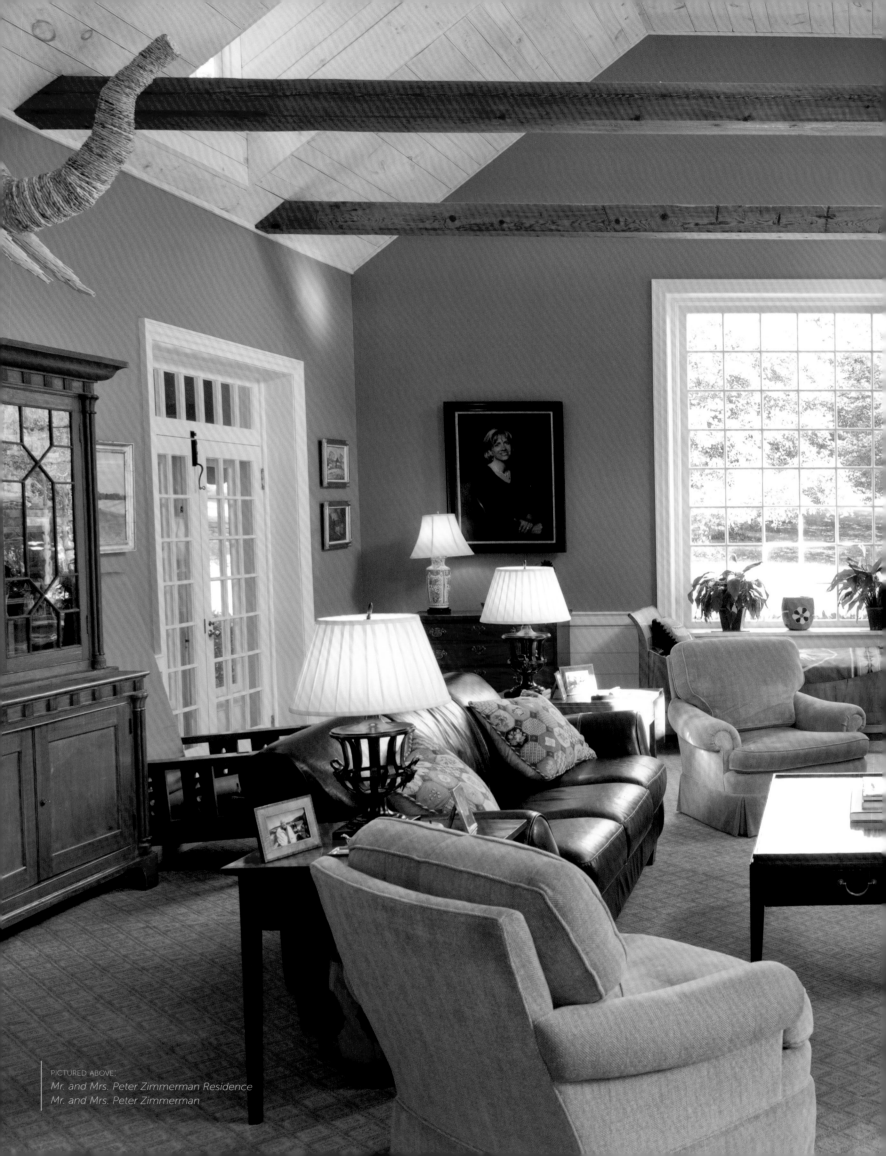

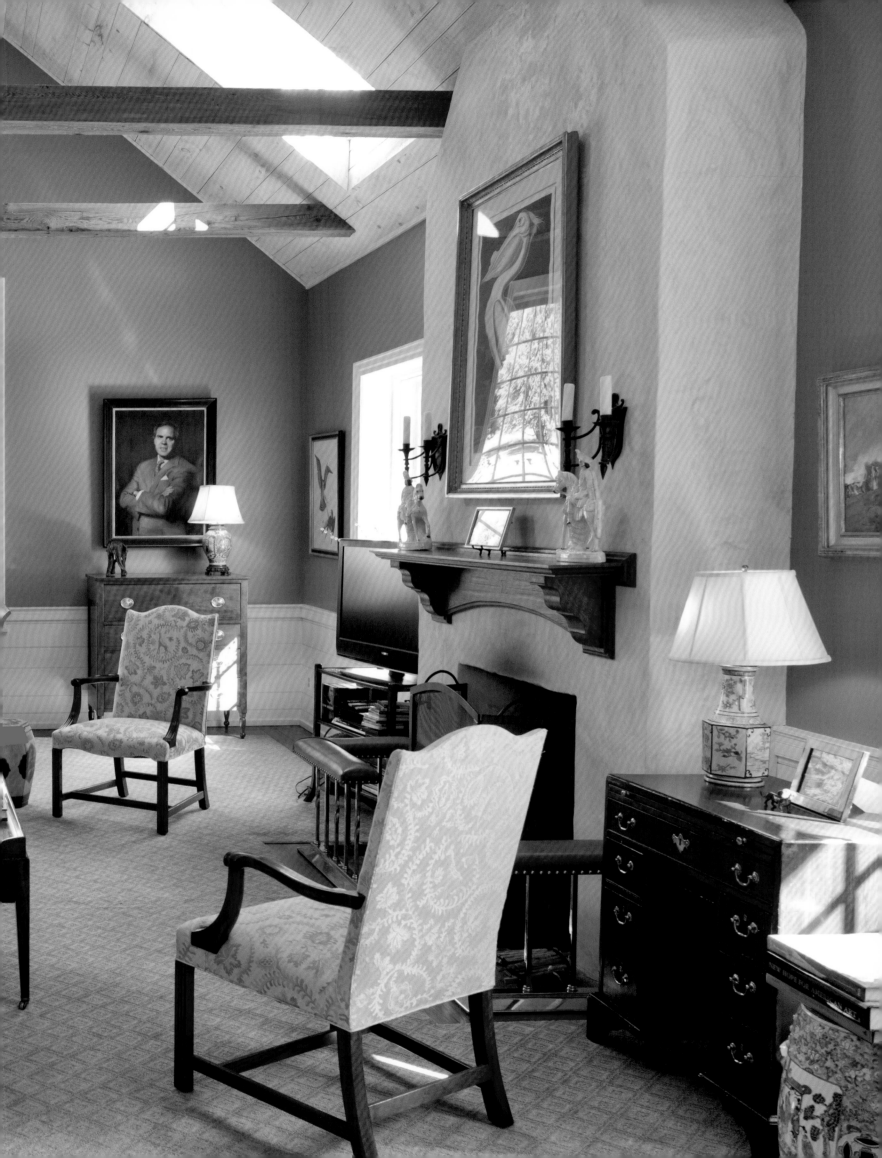

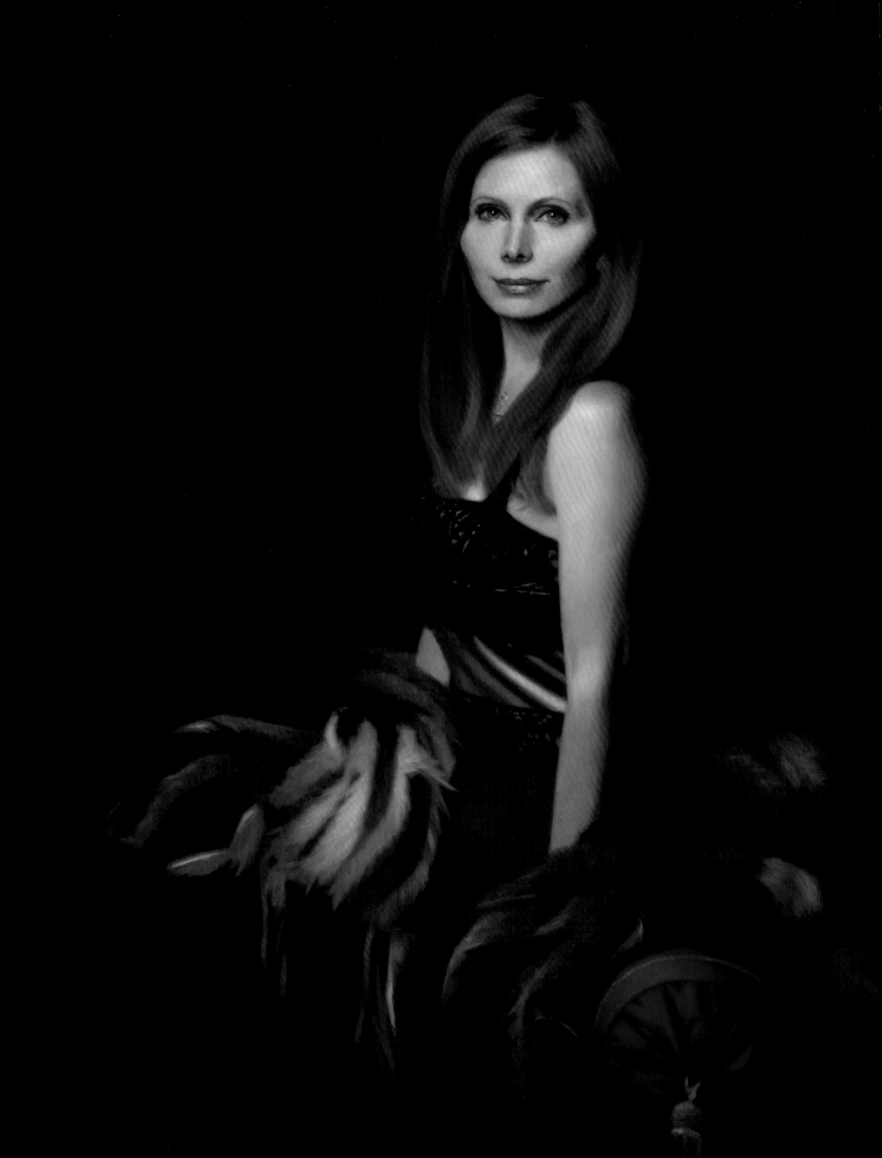

"Painting is obsessive, I forget to eat, I forget to sleep."

- Joni Mitchell

PASSION AND THE FUTURE

Perfection in painting is unattainable, which makes the pursuit of it endlessly challenging. With each painting, you get a little closer to your aesthetic ideal, but you realize it's always going to be just a little short of your goal. And this is as it should be. The process of painting should be as engaging to the painter as the product. It is the passionate exploration of the act of painting itself that makes one an artist. The resulting image merely represents the culmination of everything the painter learned while creating it. So rather than pursue a new direction in the future, I imagine my work will continue to be refined by my core tenants on what makes great painting. To be able to articulate these beliefs in paint more eloquently is my task.

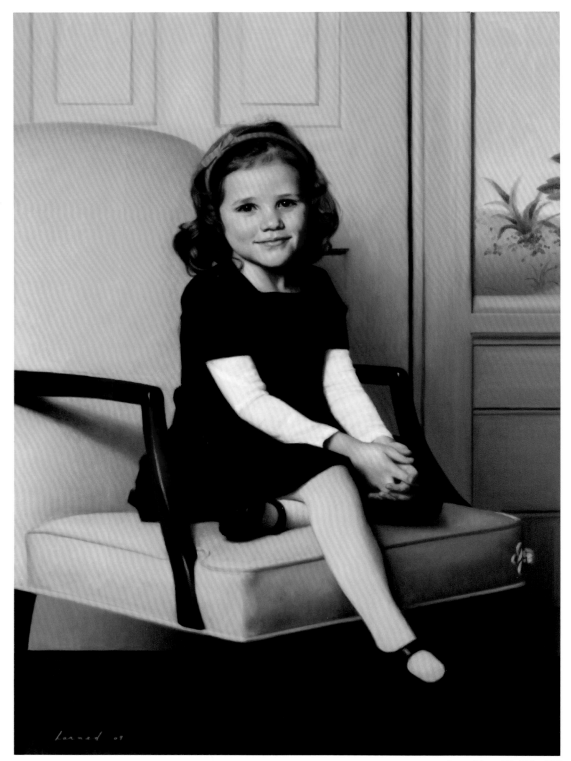

Josephine, Oil, 39" x 28"

PICTURED ON RIGHT:
Kim
Oil, 50" x 35"

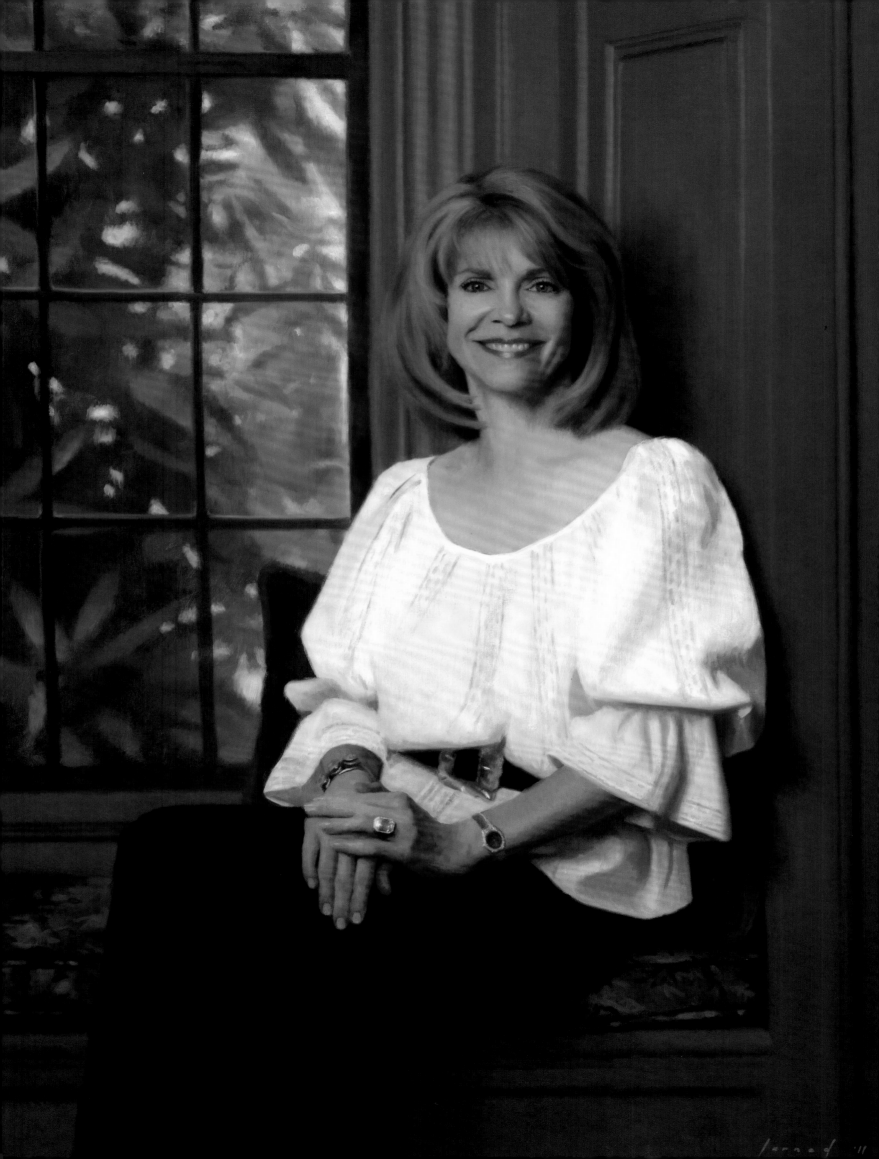

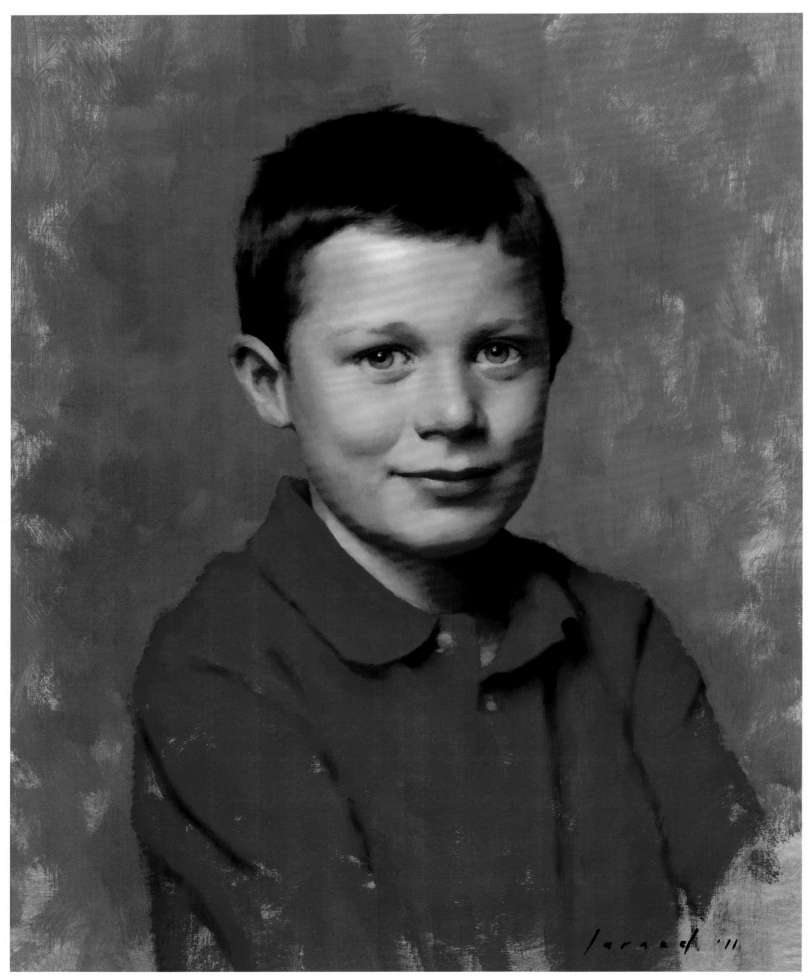

Rudy, Oil, 18" x 14"

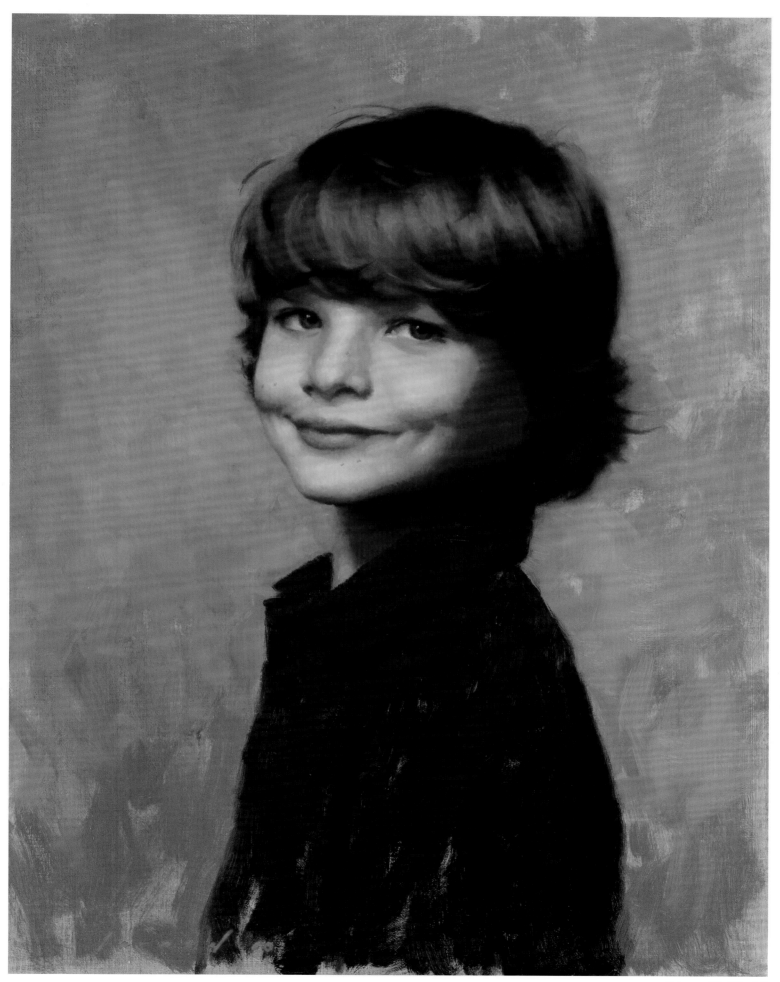

Colman, Oil, 18" x 14"

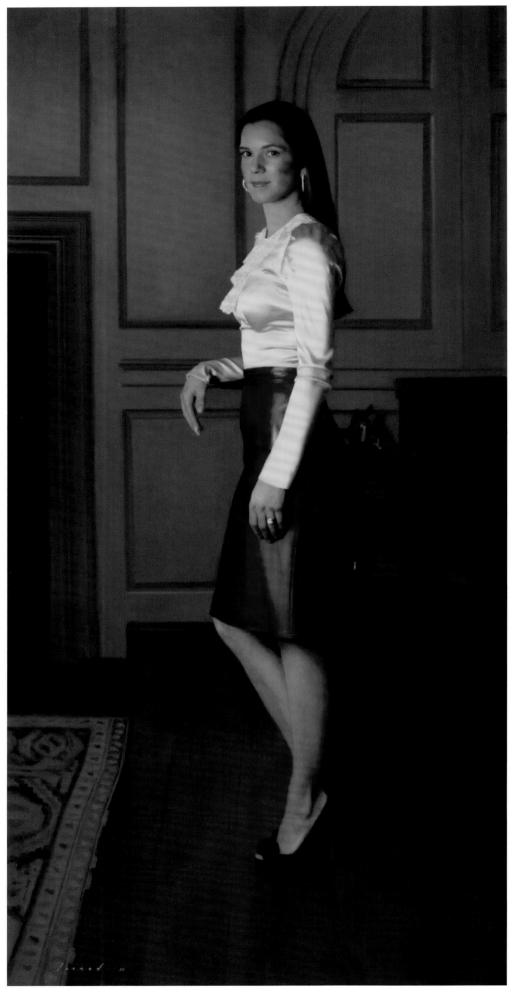

Sabrina, Oil, 82" x 40"

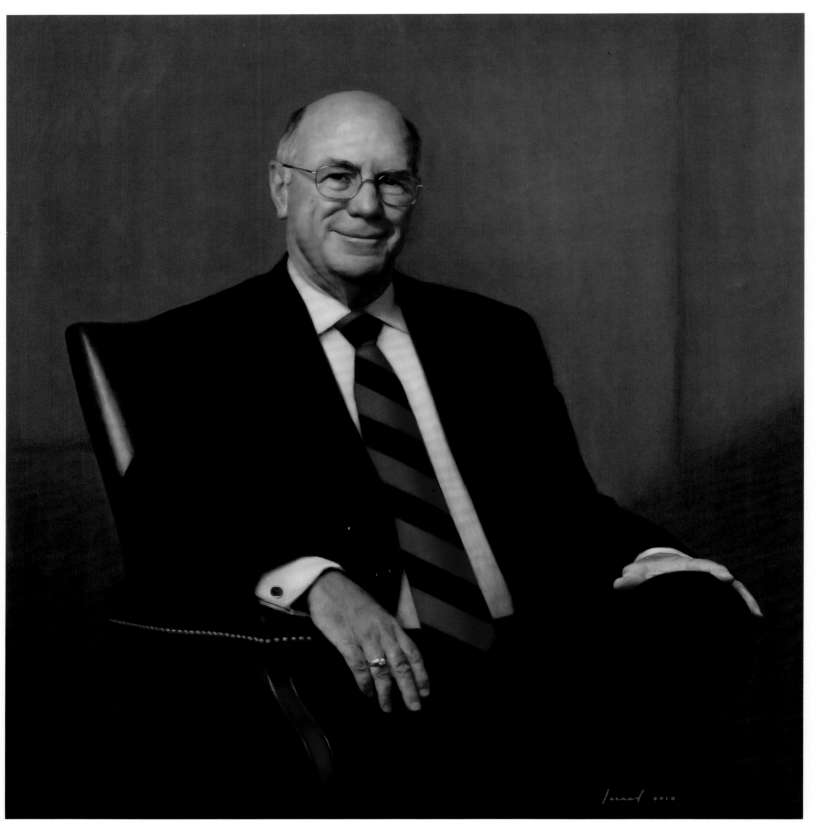

Chairman of the Board, University of Delaware, Gil Sparks, Oil, 37" x 35"

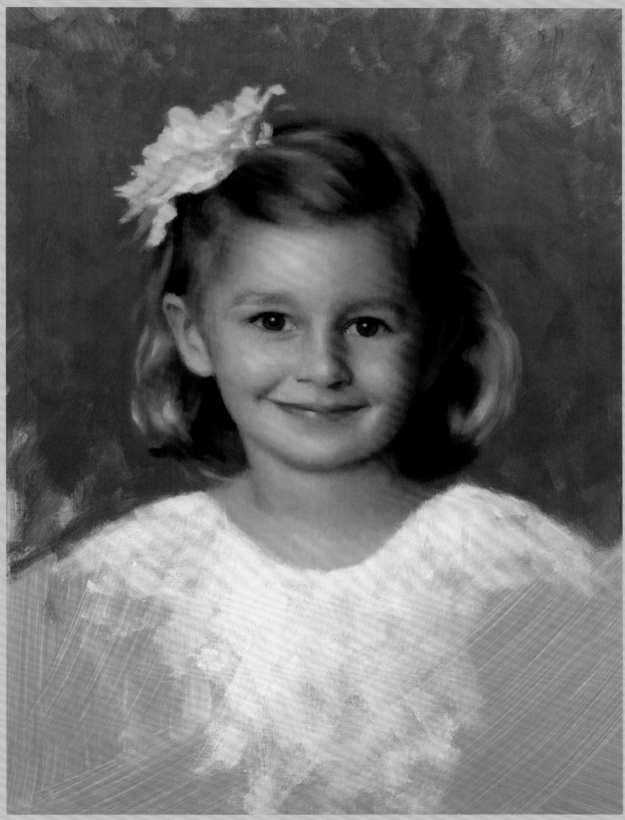

Zinnia, Oil, 18" x 14"

David Larned is one of the most inspired and talented portrait painters working today. With a Larned portrait one sees not only a remarkable likeness—but, more importantly an impressive work of art.

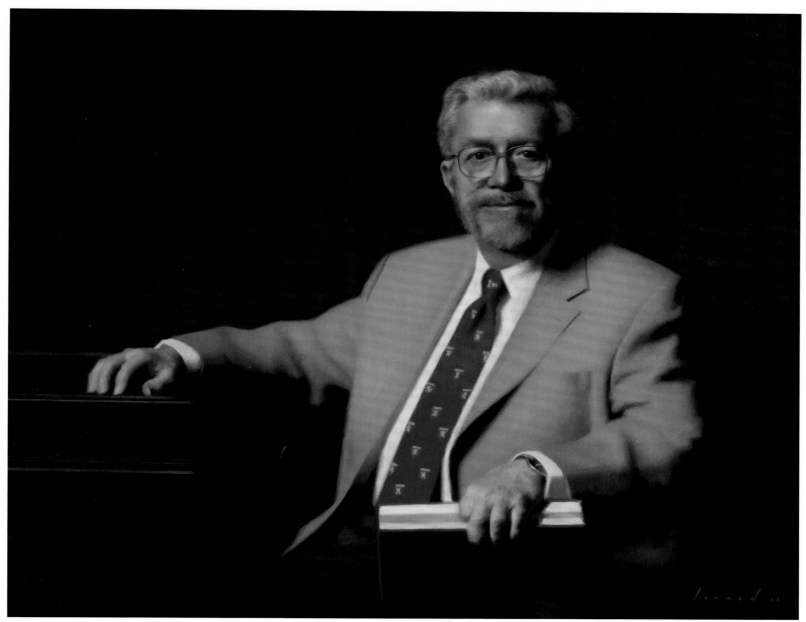

Director of Fels Institute of Government, University of Pennsylvania, Dr. James Spady, Oil, 37" x 35"

COMMENTARY

"A portrait is a representation of the likeness, personality, and/or character of an individual or group of individuals. The creator must possess an array of talents to carry off the portrait successfully. David Larned is that rare, sophisticated, erudite observer and painter who succeeds at this task as very few do. He succeeds in recording the physical and mental aspects of his subject(s) with clarity; his portraits breathe life into his subject with authority and panache. At so young an age, he is a top flight portraitist with few equals."

John Pence
John Pence Gallery
San Francisco, CA

Jamie Wyeth, Artist

David Larned's art demands and deserves a very long look. It will be studied and enjoyed for decades to come, both as part of—and as a representation of—this region, its people, and its culture. His fine and carefully wrought painting is now clearly part of our aesthetic heritage.

David's portraits are intimate letters to the sitters. Viewing them is akin to reading someone's diary. Each page is an investment of spirit and a wealth of honesty ... the brushstrokes and descriptive passages combine to illuminate the sitter's life, their surroundings, their emotion.

Mark Dance, Artist

"... particularly apt are David Larned's portraits rendered in a manner that self-consciously recalls the manner of John Singer Sargent. Their historical allusion to a traditional manner of American portraiture, far from seeming derivative, actually locates, valorizes, and somehow enhances the aura of the sitters. The style seems bestowed as a kind of gift upon its anonymous subjects, as if the artists were acknowledging that their subjects are worthy of the high manner of American portraiture."

Dave Hickey
Writer, Curator, and Cultural Critic Las Vegas
Excerpt from Smithsonian National Portrait Gallery '06 Portrait
Competition Catalog

All of Larned's portraits share certain qualities: a baroque richness of color, unique and telling gestures and a brushstroke that imbues his subjects with an inner movement. These are not paintings of hurdling athletes but of sitters who vibrate with their own personalities.

Ryan Grover
Curator, Biggs Museum of American Art,
Dover, DE

David not only delivers a fantastic likeness of his subject, but also you have the feeling that he has somehow touched their soul.

Meredith J. Long
Meredith Long Gallery,
Houston, Texas

Larned reaches beyond the canvas with intimate touch. The trusting innocence of a child; the furrowed experience of the mature, the vigorous promise of the young: His brush seizes tangible vitality with simple honesty. Look too at the canvas surface. Here we find the beauty of painting as painting. Suddenly, yet subtly, rich colors immerse us. Dense and creamy hues stir our delight. Gentle and delicate transitions illuminate the form in a beckoning and delicate warmth. We see them with a sure knowledge: tangible, moving, alive.

Tony Devaney Morinelli, Ph.D.
Humanities Chair Director of Performing Arts
The Shipley School Bryn Mawr, PA

James H. Duff, Director,
Brandywine River Museum,
Chadds Ford, PA

The eyes on a Larned canvas meet the viewer to reveal a distinct persona and a divinely created soul. Those eyes, they are the handshake, the embrace, the greeting, the invitation to know the model. Clearly, Larned's works evolve from a passion for painting, innate skill, and finely honed technique that emphatically demonstrate the power of portraiture.

Halsey Spruance
Executive Director
Delaware Museum of Natural History
Wilmington, DE

In meeting David you are struck by his authenticity, intensity, and intuition, which are all traits one would want from a portrait artist. Good art is truthful and real and his paintings push beyond mere likeness to include all these necessary elements. In so much of David's artwork you notice a spark between the sitter and the artist where he has captured an individual and it appears for a moment they have forgotten they were posing for a portrait. It is in that awareness of the spark where David's characteristics bring the portrait to its full potential.

Robert C. Jackson, Artist

The challenge which faces every portrait painter is the ability to accurately and recognizably depict his subjects not only as they are, but also as they aspire to be. Graced with enormous natural talent, David Larned captures the character and soul in his portraits of people, which is indeed the essence of a memorable and timeless work of art.

Andrew C. Rose
Art Finance Partners, LLC
New York City, NY

Having studied David Larned's portraits in an exhibition I became aware of his sensitive fusion of the real and the ethereal. His likenesses have a spiritual, almost mystical quality, and yet if you actually know any of his subjects, as I do, you recognize them instantly. As an art historian, I would equate Larned's achievement as the method by which he reveals the personality of his sitters, a feat seldom achieved. I am reminded also of the timelessness of Johannes Vermeer, whose figured studies are similarly caught in a moment of time, for which we are eternally grateful.

Douglas Hyland
Director, New Britain Museum of American Art
New Britain, CT

Portraiture is a wonderful way to slowly get back to the artist patron relationship that has become so ripped apart over the past century. Art collectors now only buy art "off the rack" so to speak. Commissioning a portrait from a painter, like commissioning a building from an architect, is a wonderful way for art lovers and artists to become connected and to inspire one another. Up until Dutch artists started to paint landscapes and still lives "on spec," virtually all great art was commissioned. Michelangelo, Caravaggio, Rubens all had their patrons who commissioned specific works of art. This artist/patron relationship did not inhibit, but sparked creativity.

Dr. Gregory S. Hedberg
Director, European Paintings & Sculpture
Hirschl and Adler Galleries, NYC

David Larned continues a tradition of portrait painting begun in the Renaissance and refined over the centuries by masters such as Titian, Rembrandt, Velazquez, and Sargent. What began as the capture of a painted likeness developed into an illuminating character study of the individual. The personality of the sitter, perhaps an important emotion, the accoutrements of profession, and a descriptive setting were often primary components. The painted portrait functioned as a memorial, or a record for the family, church, government, or institution, as well as a work of art.

The State of Delaware commissioned David to paint portraits of the First Ladies who lived at Woodburn, the Governor's residence in Dover. The special challenge was to depict them as they were when their husbands were in office—and for several that time was over twenty years ago!

As one person who has known all the women commented, "He has truly captured the person on canvas. I can see the lady I know. They are very different people, and that is obvious. These are not the usual stiff, formalized official portraits. I feel that I could have a conversation with First Lady Mrs. Wolf."

David has limited his palette in each work to a few key colors, often one warm and the other cool. This practice plus his frequently simple, neutral backgrounds and dynamic lighting heightens the subject's appearance. The textures of clothing are amazingly naturalistic. The overall effect is one of quiet drama, the viewer's expectation that a conversation with the sitter can begin.

Larned's work is especially significant in his continuation of the historic portrait tradition with a technique that stands on the shoulders of the "old masters" but is not limited to it. His sitters are decidedly of today, yet his response to them transcends a particular style or time. These are straightforward, naturalistic images that eloquently affirm the beauty of our visible world.

Karol A. Schmiegel

Director Emerita,
Biggs Museum of American Art

PICTURED ON RIGHT:
Chief of Medicine, Maine Line Health System,
Lankenau Hospital, Dr. Jerome Santoro
Oil, 45" x 33"

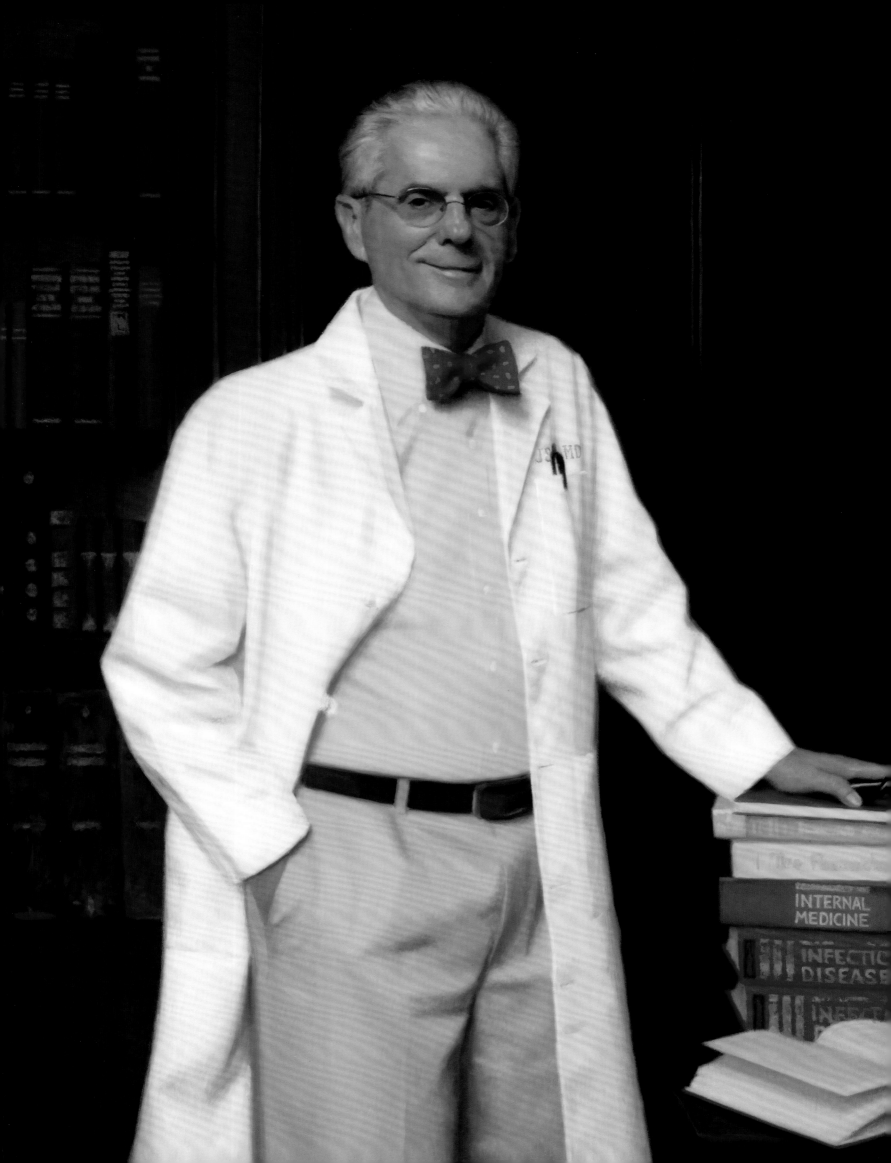

RESUME

DAVID LARNED

Born New York City, NY, 1976

EDUCATION

2003 University of Pennsylvania, B.F.A. Cum Laude, Philadelphia, PA
2000–2002 Florence Academy of Art, Florence, Italy
1997–1999 Pennsylvania Academy of the Fine Arts, Philadelphia, PA

SELECTED PUBLIC FIGURES

Governor Pierre S. du Pont IV, DE
Governor Dale E. Wolf, DE
Governor Ruth Ann Minner, DE
Governor Steven Beshear, KY
First Lady Lillian Peterson, DE
First Lady Jeanne Tribbitt, DE
First Lady Elise du Pont, DE
First Lady Jane Castle, DE
First Lady Clarice Wolf, DE
The Honorable Seamus P. McCaffery, Supreme Court of
 Pennsylvania, PA
The Honorable Joseph J. Farnan, Jr., US District Court, DE
The Honorable Sue L. Robinson, Chief Judge, US District Court, DE
The Honorable Helen S. Balick, Chief Judge, US Bankruptcy Court,
 District of DE
The Honorable Marlene F. Lachman, Common Pleas Court,
 Philadelphia, PA
The Honorable Battle Robinson, Sussex County Family Court, DE
Vice Chancellor Stephen Lamb, Delaware Court of Chancery
Rector James Bagby, St. Martins Episcopal Church, Houston, TX
Rector Claude Payne, St. Martins Episcopal Church, Houston, TX
Rector Laurence Gipson, St. Martins Episcopal Church, Houston, TX
RWGM Slater, Grand Lodge of Pennsylvania, F. & A.M., PA
RWGM Aungst, Grand Lodge of Pennsylvania, F. & A. M., PA
RWGM Gardner, Grand Lodge of Pennsylvania, F. & A. M., PA
RWGM Sturgeon, Grand Lodge of Pennsylvania, F. & A. M., PA
RWGM Smith, Grand Lodge of Pennsylvania, F. & A. M., PA
RWGS Albert, Grand Lodge of Pennsylvania, F. & A. M., PA
RWGS Haines, Grand Lodge of Pennsylvania, F. & A. M., PA
RWGT Coy, Grand Lodge of Pennsylvania, F. & A. M., PA
President David Duffy, Malvern Preparatory School, Malvern, PA
President Jim Stewart, Malvern Preparatory School, Malvern, PA
President Dr. Mary F. Seppala, The Agnes Irwin School, Rosemont, PA
Headmaster Dr. Joseph Cox, Haverford School, Haverford, PA
President Gary Graffman, Curtis Institute of Music, PA
Dr. James Spady, Director of Fels Institute of Government,
 University of Pennsylvania, Philadelphia, PA

Dean Steven P. Frankino, Villanova University School of Law, PA
Professor Ellis Wasson, PHD, University of Delaware, DE
Chairman of the Board Gil Sparks, University of Delaware, DE
John H. Ammon, John H. Ammon Medical Education Center, DE
Ruth S. Ammon, Ruth S. Ammon School of Education, Adelphi
 University, NY
Board of Trustees Chair Katherine Gahagan, St. Andrews School, DE
Clifford Michel, Michel Athletics Building, St. Marks School, MA
Chief of Medicine Dr. James Santoro, Lankenau Hospital,
 Wynnewood, PA
Chief of Medicine Dr. Robert Flinn, Christiana Care Health System, DE
President and CEO Dan Tutcher, Enbridge Energy Company, Inc.,
 Houston, TX
President and CEO Dennis Klima, Bayhealth Medical Center, Dover, DE
President and CEO Don Gagnon, AAA Mid-Atlantic, Inc., Wilmington, DE
Chairman and CEO Lon Greenberg, UGI Corporation, Valley Forge, PA
CEO Marvin Schoenhals, W.S.F.S, DE
CEO Dan Butler, Corporation Service Company, DE
CEO Tom Ferry, Nemours/Alfred I du Pont Hospital for Children, DE
CEO and President H.L. Pepper, The Chester County Hospital and
 Health System, PA
Founder Foster Friess, Friess and Associates and the
 Brandywine Funds, WY
Founder Tom H. Draper, Draper Holdings Company, DE
President General George Forrest Pragoff, The Society of the
 Cincinnati, DC
President Brian Crochiere, Merion Cricket Club, Philadelphia, PA

EXHIBITIONS, SOLO/GROUP

2012 *Portraits*, Meredith Long Gallery, Houston, TX
2008 *Recent Works*, John Pence Gallery, San Francisco, CA
2006 *Interiors*, John Pence Gallery, San Francisco, CA
2006 *Recent Works*, Pierre S. du Pont Arts Center, Wilmington, DE
2006 *Recent Works*, Barbara Gisel Design Gallery, Haverford, PA
2004 *New Works*, Biggs Museum of American Art, Dover, DE
2003 *Portraits*, Artist's House Gallery, Philadelphia, PA
2003 *Self Portraits*, John Pence Gallery, San Francisco, CA
2003 *Realism Revisited*, Hirschl and Adler Gallery, New York City, NY
2003 *The Sea Coast Near and Far*, Susan Powell Gallery, Madison, CT
2003 *Still Classical*, Westbeth Gallery, New York City, NY
2003 *Annual Student Exhibition*, Pennsylvania Academy of the Fine Arts,
 Philadelphia, PA
2003 *Drawn To You*, Moore Gallery, Philadelphia, PA
2002 *Winter Certificate Exhibition*, Pennsylvania Academy of the Fine Arts,
 Philadelphia, PA

2002 *Learning the Classical Way,* Pierre S. du Pont Arts Center, Wilmington, DE

2002 *Landscapes from Tuscany and the Brandywine Valley,* Delaware Center for Contemporary Art, Wilmington, DE

2001 *Recent Works,* Design Elements, Wilmington, DE

2000 *New Talent Exhibition,* Gross McCleaf Gallery, Philadelphia, PA

AWARDS

2009 Outwin Boochever Portrait Competition Semi-Finalist
Smithsonian National Portrait Gallery, Washington, D.C.

2006 Outwin Boochever Portrait Competition Semi-Finalist
Smithsonian National Portrait Gallery, Washington, D.C.

2003 Earl T. Donelson Figure Painting Prize
Pennsylvania Academy of the Fine Arts, Philadelphia, PA

2003 Historic Yellow Springs Landscape Prize
Pennsylvania Academy of the Fine Arts, Philadelphia, PA

2003 Seymour Remenick Memorial Prize
Pennsylvania Academy of the Fine Arts, Philadelphia, PA

2002 National Collegiate Scholar
University of Pennsylvania NSCS Chapter, Philadelphia, PA

BIBLIOGRAPHY

2013 Maine Home and Design, "Air and Light," Debra Spark, January

2010 The Hunt, "The Sitter and the Painter," Roger Morris, Winter

2010 "Star Wars Visions," George Lucas, J.W. Rinzler

2010 "100 Artists of the Brandywine Valley," Catherine Quillman

2009 Palm Beach Illustrated, "The Style Files," October

2008 American Art Collector, "Daily Observations," November

2008 American Art Collector, "A San Francisco Summer," July

2008 The News Journal, "Del.'s first ladies have their own wall now," November 28

2008 American Art Collector, "A San Francisco Summer," July

2008 Chester County Town & Country Living, "A Study of Light, Surface, Personality, and Food"

2008 Chester County Life, "Embracing the Man, Mission, and Arts," May/June

2008 PBS, WHYY, Delaware Tonight, "Portrait of an Artist," March 27

2007 Greenville News, "Clarice Wolf's portrait to be unveiled in governor's mansion," October 9

2006 Smithsonian National Portrait Gallery Competition, "A Lost World Found"

2004 Art Talk, "Mastery Triumphant in San Francisco," April

2004 Delaware Today, "Hot Tickets," February

2004 The Dover Post, "Contemporary Portraitist," January 21

2004 The Cape Gazette, "Larned Exhibit," January 2

1996 Vermont Quarterly, "The Body in the Mind's Eye," Winter

TEACHING

2002 Sculpture Drawing Program Head
Florence Academy of Art, Florence, Italy

MEMBERSHIPS

Portrait Society of America

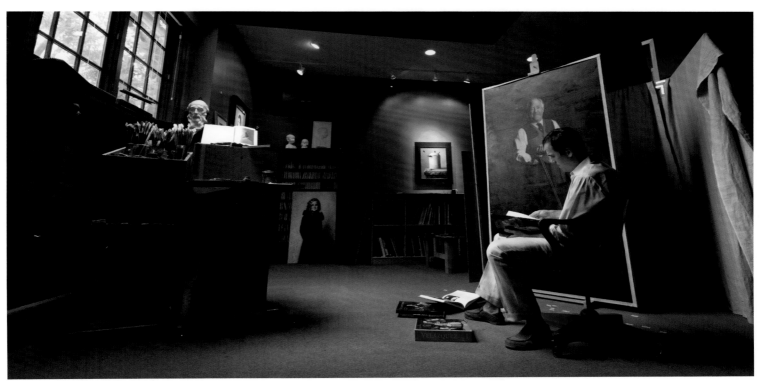

David Larned in his studio

"Even in literature and art, no man who bothers about originality will ever
be original: whereas if you simply try to tell the truth (without caring two pence
how often it has been told before) you will, nine times out of ten,
become original without ever having noticed it."

- C.S. Lewis, *Mere Christianity*

David Larned, Portraits
©2013 by David Larned

Edited by Jennifer Bright Reich

Photographs by Alessandra Manzotti

Designed by Cynthia Oswald

Printed by Brilliant Press